IMAGES
of America

SOCORRO

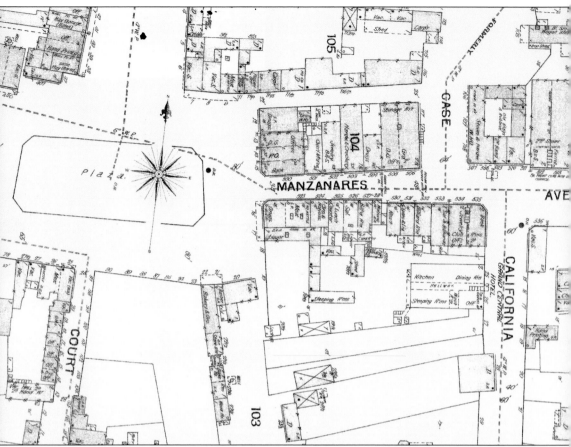

The Sanborn Company began making maps to assess fire insurance liability in urban areas in 1867. In addition to mapping the street layout, Sanborn surveyors noted building footprints, construction materials, proximity to gas and water lines, and the presence of concentrations of flammable materials, such as hay and grain storage areas. This Sanborn map shows Socorro's Plaza and Kittrell Park area. (Courtesy of Suzanne Smith, Joseph E. Smith Collection.)

ON THE COVER: Enthusiastic Republicans from throughout New Mexico gathered at the top of Socorro Mountain to show their support for the presidential campaign of Theodore Roosevelt in the summer of 1904. Roosevelt won the election, defeating the Democratic candidate, Alton B. Parker. (Courtesy of Socorro County Historical Society.)

IMAGES
of America

SOCORRO

Baldwin G. Burr

ARCADIA
PUBLISHING

Published by Arcadia Publishing
Charleston, South Carolina

Printed in the United States of America

Library of Congress Control Number: 2014943791

For all general information, please contact Arcadia Publishing:
Telephone 843-853-2070
Fax 843-853-0044
E-mail sales@arcadiapublishing.com
For customer service and orders:
Toll-Free 1-888-313-2665

Visit us on the Internet at www.arcadiapublishing.com

This book is dedicated to Joseph E. Smith.

CONTENTS

ACKNOWLEDGMENTS

Many people provided valuable assistance to me while I was writing this book. I am grateful to Socorro County Historical Society members Paul Hardin, Wotan Heatwole, and Jon Spargo for providing much information about the history of Socorro and surrounding communities. Dr. Richard Melzer, University of New Mexico Valencia Campus, read and commented on early drafts of the book. Andrea Chavez and Ricardo Gonzales, with the Los Lunas Museum of Heritage and Arts, read and critiqued the text, helped with research, and provided invaluable moral support.

I would like to thank Bill Hill and Michael Jaramillo of Belen, New Mexico, and David Ortiz of Los Lunas, New Mexico, for providing photographs and documents from their extensive private collections.

I am particularly grateful to Bob Eveleth, president of the Socorro County Historical Society, and Suzanne Smith, great-granddaughter of photographer Joseph E. Smith. These two individuals were not only great sources of information, but gracious hosts as well. Their support will always be appreciated.

Finally, I would like to acknowledge the encouragement and support I have received from my wife, Laura Burr. Nothing gets my attention like her saying, "Are you sure you want to write it that way?"

INTRODUCTION

The name *Socorro* was given to the place that would become Socorro, New Mexico, by Don Juan de Onate, because he and his fellow Spanish explorers found "succor" there. Socorro was an oasis at the end of a 90-mile stretch of El Camino Real, the ancient road between Chihuahua, Mexico, and Santa Fe. This route, through inhospitable desert, was called La Jornada del Muerto, "the journey of the dead man."

The original inhabitants of Socorro were Piro Pueblo people, numbering between 5,000 and 8,000 when the Spaniards arrived in New Mexico. They had a highly developed society and worked and lived in relative peace with the Spaniards. They intermarried with the Spaniards and helped them build the churches at Socorro, Senecu, and Sevilleta. When the Northern Pueblos revolted against their Spanish rulers in 1680, the Piro fled south on the Jornada to El Paso, Texas, along with the Spanish inhabitants of Socorro. They did this rather than join in the revolt. Over 800 Piros perished on the trip, a result of their decision to remain loyal. This was reason enough for this section of El Camino Real to be called La Jornada del Muerto.

Although New Mexico was reconquered by Diego de Vargas in 1692, Socorro was not resettled by the Spanish until 1816. A small community grew up around the San Miguel Catholic Church, and the Spanish settlers engaged in subsistence agriculture, raising just enough crops and livestock to maintain their own families. Spanish rule in Socorro ended in 1821. The Spanish government in Mexico City had forbidden trade with the United States, but after the revolution of 1821, El Camino Real was joined with the Santa Fe Trail, and trade flourished.

Estanislao Montoya engaged in the first known mining activity in the Socorro area, in 1840, on a property that would become known as the Merritt Mine. But he was forced to abandon his efforts due to Indian raids. The US government established several forts in an effort to control the Indians. One of those was Fort Craig, located about 30 miles south of Socorro. In addition to increasing the security of settlers in the area, Fort Craig also represented a significant market for goods and services from Socorro.

In 1866, Col. John S. "Old Hutch" Hutchason and Pete Kinsinger discovered rich silver deposits in the Magdalena Mountains west of Socorro. These two men were soon joined by others as they gradually developed the mineral wealth of the area. When the Atchison, Topeka & Santa Fe Railroad arrived in Socorro in 1880, all the elements were in place for a major economic boom.

New communities developed around mining activity in Socorro County. Magdalena and Kelly, located 26 miles west of Socorro, grew rapidly in the 1880s. Both towns soon had thriving mercantile businesses, hotels and boardinghouses, churches, and schools. Coal deposits were found south of Socorro, at Carthage, also an important mining community. A railroad spur line between Carthage and San Antonio was built to ship coal and coke to smelters in Socorro. Coal was also shipped to San Marcial, a few miles south of San Antonio, where it was used to fuel railroad locomotives.

Gustav Albert Billing came to Socorro in 1882 after building successful smelting operations in Salt Lake City, Utah, as well as Leadville, Colorado. He purchased the Kelly Mine and built a

smelter a few miles southwest of the Socorro Plaza. The smelter, fueled by coal from the Carthage coal mine, processed the raw ore from the mines at Kelly into more compact, financially efficient bars. Billing's smelter could process one ton of silver ore into seven bars, or pigs, of bullion. The bullion was then shipped to St. Louis for further refining. Most of the bullion processed by Billing's smelter was silver and lead. One million ounces of silver and almost 5,000 tons of lead were processed between 1885 and 1889. Through the efforts of Gustav Billing, Socorro became the smelting capital of a geographic area that included New Mexico, eastern Arizona, western Texas, southern Utah, and even northern Mexico.

The railroad expanded the market for cattle, sheep, and other agricultural products, and Socorro was the shipping point for those products. Farming and ranching activity increased to fill the new demand for agricultural products. Alfalfa, oats, rye, barley, cabbages, beets, potatoes, onions, and chilies were all raised, but wheat and corn were the main field crops. There were orchards of apples, pears, peaches, plums, apricots, and quinces. There were also many vineyards and wineries. Flour mills were built in Socorro to process the wheat grown by area farmers. Flour processed in Socorro went to military forts in New Mexico, Colorado, and Arizona, and was shipped by the railroad to more distant markets throughout the West. Socorro County contained nearly four million acres of grazing land, and many ranches drove their cattle to the stock pens at Magdalena for shipment to distant markets. The Magdalena Stock Driveway, which extended from eastern Arizona to Magdalena, was active for nearly 100 years, from 1885 until 1970.

The prosperity of the boom era in Socorro can still be seen in several architecturally striking houses that have survived. The Juan Nepomuceno Garcia house, the Juan Jose Baca house, the Garcia Opera House, the Anastacio Sedillo house, and the Jacabo Sedillo house are just some of the structures still standing. Other historic Socorro houses are those that belonged to Ethan W. Eaton and Holm O. Bursum.

The good times were not to last, however. The successful smelting operations were hampered by competition for the ore from competing smelters in El Paso and northern Mexico. Cave-ins at the Kelly Mine further reduced the ore available to the smelter. Most seriously, the federal government demonetized silver in 1893, dramatically reducing its price. When the smelter finally closed, 400 men in Socorro lost their jobs. The recently opened New Mexico School of Mines had to close temporarily, and when it reopened in September 1895, the college also acted as the high school for the city of Socorro, which was hard pressed to keep its high school open.

Socorro did not disappear after the mining boom was over, however. Major highway and railroad routes passed through the city, and the agricultural advantages that had given rise to the town in the first place had not disappeared. Natural forces became more important to the prosperity of the town than the industrial base that had previously supported it. Fires and floods, major events in Socorro, became the major defining elements in the town's history.

One

THE OASIS AT THE
END OF THE TRAIL

Socorro is located toward the northern end of El Camino Real de Tierro Adentro, the "Royal Highway to the Interior Lands," between Chihuahua, Mexico, and Santa Fe, New Mexico. The area was abandoned by the Spanish after the Pueblo revolt of 1680, and it was not reinhabited until 1816.

The presence of abundant water from Socorro Springs, coupled with fertile soil along the Rio Grande, and a mild climate, made conditions ideal for agriculture. Livestock, field crops, and extensive orchards and vineyards were all successfully raised by local farmers and ranchers.

Mining activity in the nearby mountains, and the arrival of the railroad in Socorro in 1880, ushered in boom times and fueled dramatic growth not only in Socorro, but also in the neighboring communities of Kelly, Magdalena, San Antonio, and San Marcial. New mercantile businesses were started, and many hotels were available to serve the rapidly increasing population. In 1889, the New Mexico School of Mines was established, and the school became a major part of the fabric of life in Socorro. By 1900, however, the boom was over, and Socorro returned to its agricultural heritage.

Today, technology is once again an important element in Socorro's economy. The School of Mines is now the New Mexico Institute of Mining and Technology. The Karl G. Jansky Very Large Array Radio Telescope and research at the nearby Stallion Range of the White Sands Missile Range also contribute to this technological base.

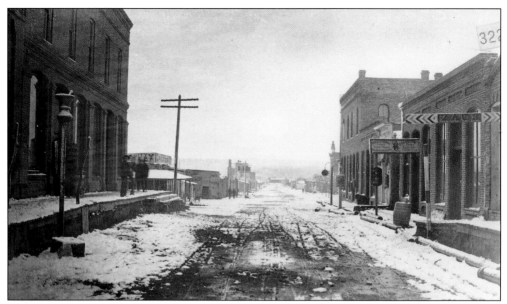

This photograph of Manzanares Avenue in winter looks east toward the Atchison, Topeka & Santa Fe Railroad depot around 1885. The Sperling Brothers Dry Goods store is on the left. At one time, Manzanares Avenue was Socorro's main street. Later, California Street became the major commercial thoroughfare in the town. (Courtesy of Suzanne Smith, Joseph E. Smith Collection.)

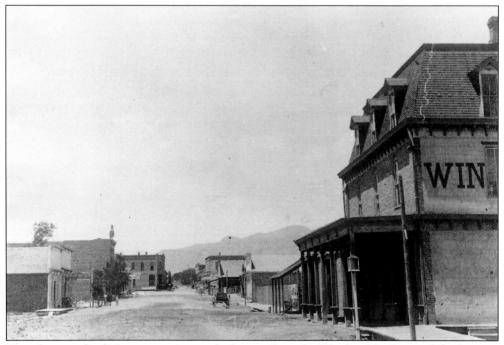

This photograph of Manzanares Avenue looks west from the Windsor Hotel toward the Socorro Mountains. The Windsor was one of several hotels and boardinghouses that served Socorro's travelers and temporary residents. (Courtesy of Socorro County Historical Society.)

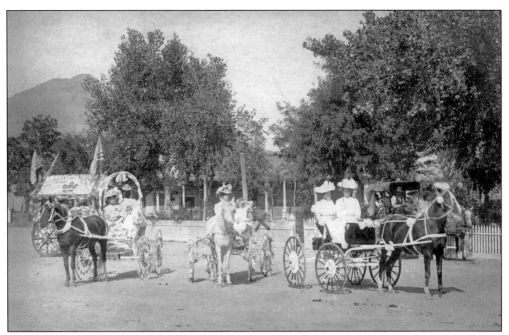

The town of Socorro developed around three parks: San Miguel Park, Isidro Baca Park, and Kittrell Park. This photograph was taken in front of Kittrell Park in the 1890s. Shown here are, from left to right, Lena Price and Dorothy Bowman in the left carriage, Louise Newcomb Martin and Claire Bursum in the center carriage, and an unidentified woman and a Mrs. Twining in the carriage at right. (Courtesy of Socorro County Historical Society.)

This photograph of the southeast corner of the plaza was taken sometime after 1920. The Model-T automobile is parked in front of Judge Amos Green's pool hall, which was the Capitol Bar before Prohibition. After the repeal of the 19th Amendment, the establishment once again served liquor. (Courtesy of Socorro County Historical Society.)

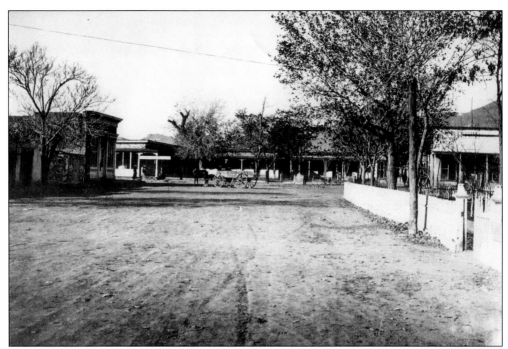

This photograph was taken from the southwest corner of the plaza, looking north. The Park House Hotel, named for its proximity to Kittrell Park, can be seen just beyond the two-story building on the left. (Courtesy of Socorro County Historical Society.)

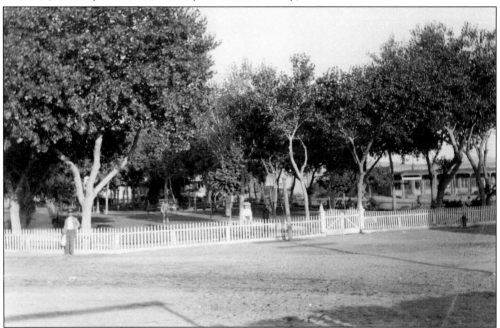

The Socorro Plaza surrounds Kittrell Park. This tree-shaded oasis in the middle of town served as a gathering place for many activities. Dr. L.W. Kittrel, a dentist and one-time postmaster of Socorro, personally maintained the park. It is believed that when he passed away in 1916, he was buried in the park that was then named after him. (Courtesy of Socorro County Historical Society.)

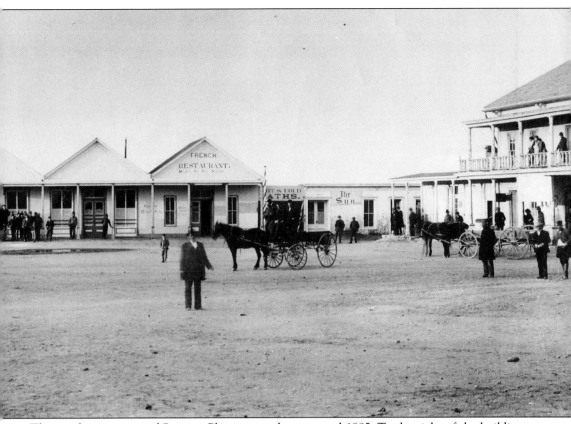

The northeast corner of Socorro Plaza is seen here around 1885. To the right of the building advertising hot and cold baths is the structure housing the Socorro newspaper, the *Sun*. The paper was edited by A.M. Conklin until he was murdered in 1880. His widow, Margaret Conklin, ran the newspaper until 1882, when she moved to Beaver City, Nebraska. (Courtesy of Socorro County Historical Society, Joseph E. Smith negative no. 468.)

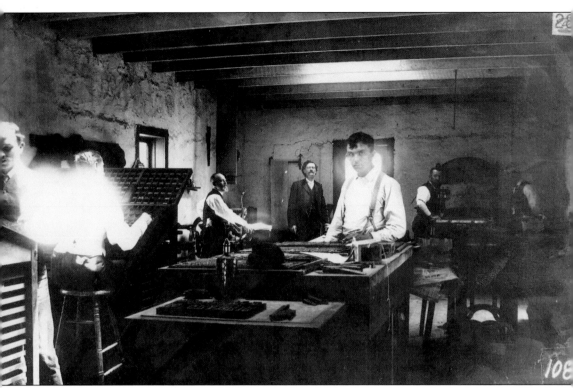

In 1882, Margaret Conklin stepped down as editor of the *Sun* newspaper in Socorro. In 1884, the *Socorro Chieftain* was founded, using type and printing equipment that once belonged to the *Sun*. This Joseph E. Smith photograph shows the interior of the *Socorro Chieftain* office around 1886. (Courtesy of Suzanne Smith, Joseph E. Smith Collection.)

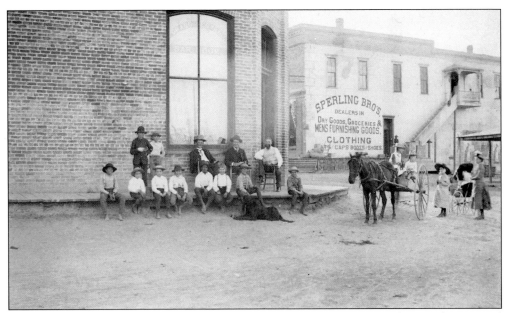

These people are seated outside the Grand Central Hotel. The two-story Sperling Brothers general store is in the background. This photograph, taken by Edward M. Bray around 1889, looks west up Manzanares Avenue. These buildings were located at the corner of Manzanares Avenue and California Street. (Courtesy of Socorro County Historical Society.)

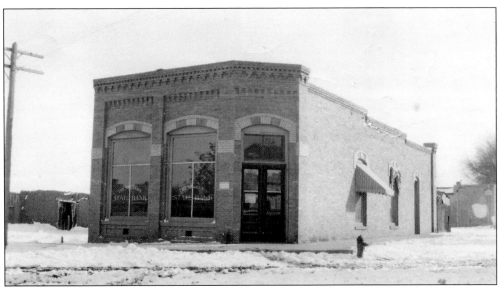

The Socorro State Bank building, pictured here around 1910, is the same building that once housed the Grand Central Hotel bar room. The front facade was originally wood; the building was plastered and painted to resemble limestone. After being remodeled several times, the building was razed in 1964, when California Street was widened. (Courtesy of Socorro County Historical Society.)

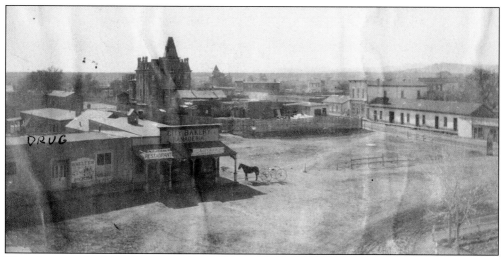

This photograph of the plaza was taken around 1885, probably from the roof of the Hilton Drug Store. The editor of the *Socorro Gazette* said this about Socorro: "This is a typical New Mexican town. Adobe buildings, heat, sand storms and Spanish-Americans, with the single exception of its possessing an abundance of shade trees. . . . The talk from daybreak to sunset is mines." (Courtesy of Socorro County Historical Society, Joseph E. Smith negative no. 563.)

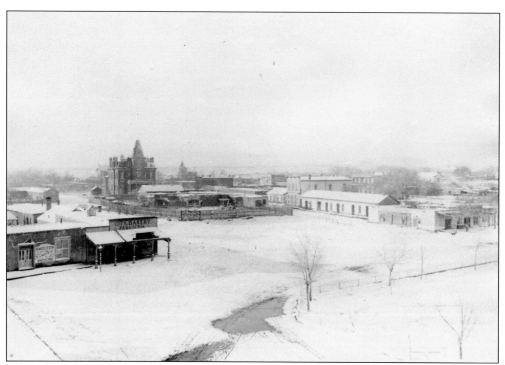

This photograph, offering a nearly identical view to the previous photograph, makes clear that, although it does not happen very often, snow does fall in Socorro. (Courtesy of Socorro County Historical Society.)

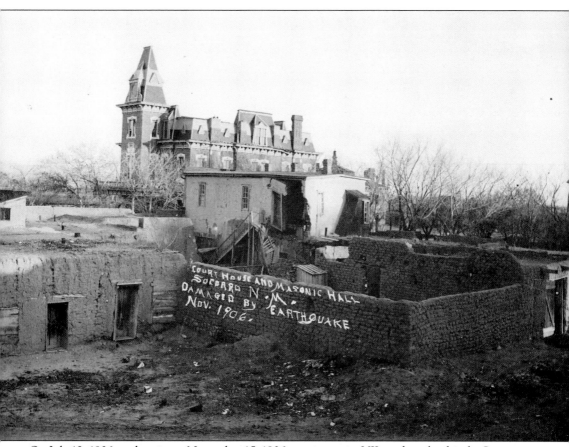

On July 12, 1906, and again on November 15, 1906, two intensity-VII earthquakes hit the Socorro area, affecting the communities of Socorro, Magdalena, San Antonio, and San Marcial. The quake shook four chimneys off the courthouse, and the Masonic temple was badly damaged. Tremors were felt daily, well into 1907. (Courtesy of Suzanne Smith, Joseph E. Smith Collection.)

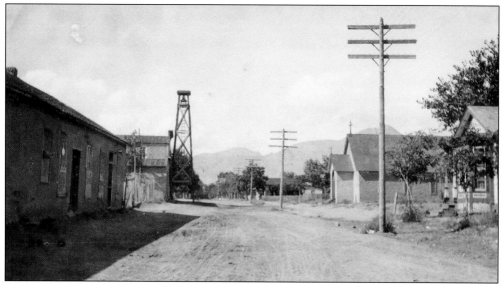

This west-facing photograph was taken on Fisher Avenue. The Epiphany Episcopal Church, which is still standing, is on the right. The "M" on Socorro Mountain can barely be seen to the right of the telephone pole. The wooden bell tower stands in front of the fire station. (Courtesy of Socorro County Historical Society.)

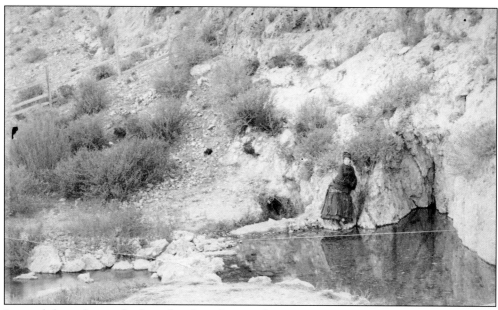

Located about three miles from the plaza, Socorro Spring is a warm spring that forms a pool that was used for many years for bathing. The spring was owned at one time by Jacobo Sedillo, who charged people 25¢ to swim there. He sold the spring and its water rights to the city of Socorro in 1949. (Courtesy of Suzanne Smith, Joseph E. Smith Collection.)

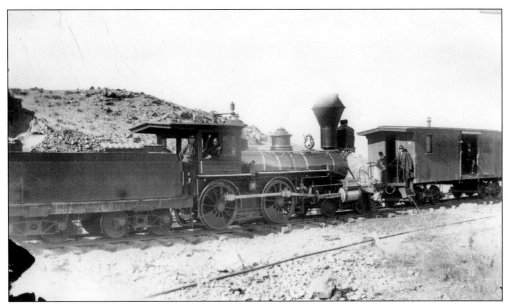

The Atchison, Topeka & Santa Fe Railroad arrived in Socorro on August 12, 1881. It brought miners, merchants, and homesteaders to the area. The railroad also provided jobs, cash wages, and access to distant markets for products from farms, ranches, and mines located nearby. This locomotive is on a siding near the rock quarry just outside of Socorro. (Courtesy of Suzanne Smith, Joseph E. Smith Collection.)

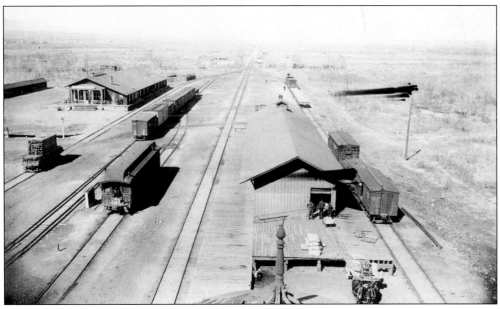

This is the Atchison, Topeka & Santa Fe Railroad depot in Socorro. The depot was located at the eastern end of Manzanares Avenue. The Brown and Manzanares Mercantile Company can be seen in the upper left of this photograph, which was taken from the top of the water tower in the 1880s. (Courtesy of Suzanne Smith, Joseph E. Smith Collection.)

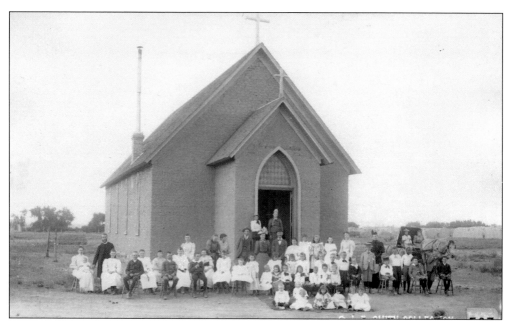

Epiphany Episcopal Church at 219 Fisher Avenue was built in 1886. It was constructed of adobe in the Gothic Revival style, as indicated by the pointed arches on the door and windows. The building served the congregation until the 1960s. It is now the Knights of Pythias Hall. (Courtesy of Socorro County Historical Society, Joseph E. Smith negative no. 537)

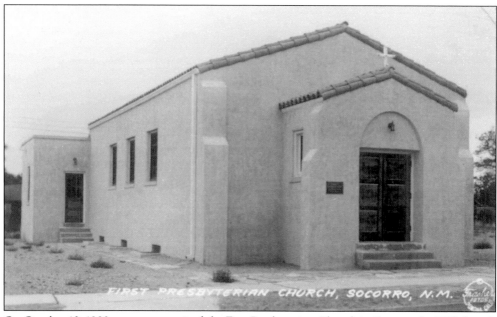

On October 13, 1880, a group organized the First Presbyterian Church in Socorro. In 1933, Joseph E. Smith and his wife, Myscie, donated land on the south side of McCutcheon Avenue for a new building for the Presbyterian Church. The church, pictured here, was dedicated in February 1936. (Courtesy of Suzanne Smith, Joseph E. Smith Collection.)

On Christmas Eve, 1880, A.M. Conklin, elder of the Presbyterian church in Socorro and editor of the *Socorro Sun* newspaper, broke up a disturbance at the back of the sanctuary, pictured here, involving Antonio Baca and two of his cousins, Onofre and Abran Baca. The Bacases left the church without incident, but when Elder Conklin later departed for home, the Bacases shot and killed him. The failure of Sheriff Juan Maria Garcia (a relative of the Bacases) to pursue the murderers led to the formation of the vigilante Socorro Committee of Public Safety, headed by Col. Ethan Eaton. Socorro was governed by lynch law for the next three years. (Courtesy of Suzanne Smith, Joseph E. Smith Collection.)

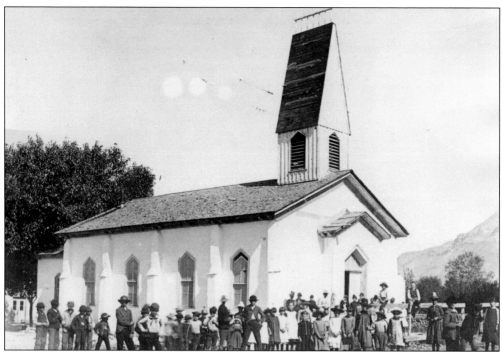

This is the Spanish Methodist Episcopal church, photographed by Joseph E. Smith around 1890. The church was located at the west end of Death Alley (the present Garfield Street). Methodist Episcopal missionary Rev. Thomas Harwood arrived in New Mexico in 1869 and founded the Spanish Methodist Episcopal Church in 1873. (Courtesy of Socorro County Historical Society, Joseph E. Smith negative no. 539.)

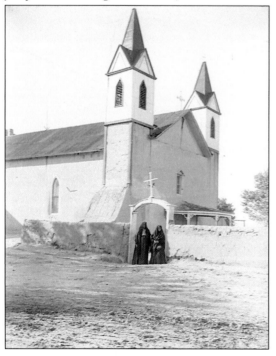

San Miguel Mission, built between 1819 and 1821, is probably erected on the ruins of an earlier church that was destroyed during the Pueblo Revolt of 1680. The church originally had a flat roof, but the bell towers were added in 1869; in 1900, the flat roof was replaced with a pitched roof. In 2010, a major remodel began. This photograph was taken around 1905. (Courtesy of Suzanne Smith, Joseph E. Smith Collection.)

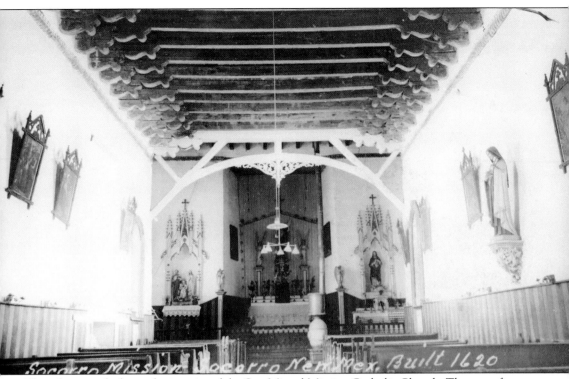

Socorro Mission Socorro New Mex. Built 1620

This photograph shows the interior of the San Miguel Mission Catholic Church. There are four subfloors under the church, and four priests and Manuel Antonio Armijo, the last territorial governor of New Mexico, are said to be buried there. The parish of San Miguel presently has six permanent missions: Alamillo, Polvadera, Lemitar, Luis Lopez, San Antonio, and Magdalena. (Courtesy of Michael Jaramillo.)

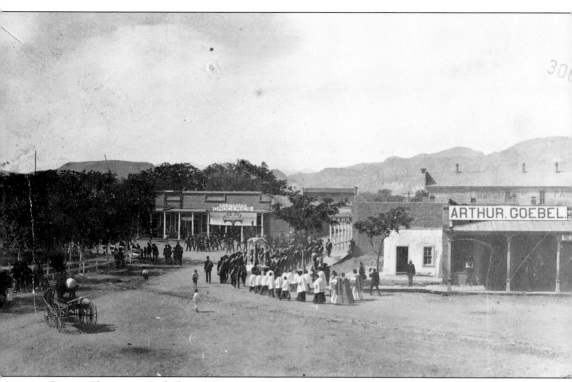

Corpus Christi is a Catholic celebration of the Eucharist. San Miguel Mission parishioners would construct an outside altar, with the men building the structure and the women decorating it with sheets, lace, and jewelry. Church members would then parade the altar around the plaza, returning to the church, where the priest would perform the ritual of benediction, thereby blessing the congregation. (Courtesy of Suzanne Smith, Joseph E. Smith Collection.)

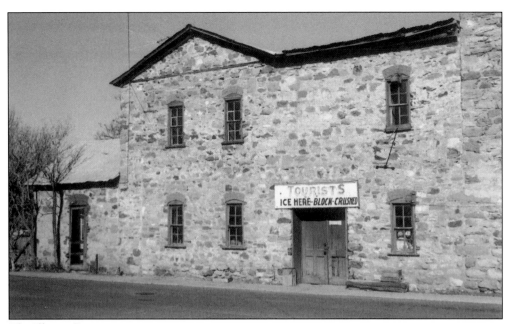

The Illinois Brewing Company was opened in this building by William Hammel, his brother Gustav, and Adam Emig in 1882. The company sold beer imported from the brewery operated by Hammel's father, Jacob, in Illinois, and sold its own beer under the brand name Export Beer, brewed with water from the springs at Socorro Peak. Jacob Hammel joined his sons in Socorro in 1887. (Courtesy of Socorro County Historical Society.)

The Illinois Brewing Company, in addition to its brewing activities, also had an ice plant. This order, from a company in San Marcial in March 1915, is for 500 pounds of ice. The order was signed by Emil Grandjean, manager of the San Marcial Mercantile Company. Grandjean was born in Switzerland in 1866. (Courtesy of Michael Jaramillo.)

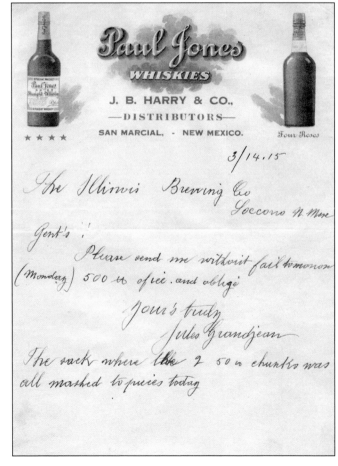

In addition to beer imported from Clarence Hammel's father's brewery in the Midwest, the Illinois Brewery also produced its own brands, including Celebrated St. Louis Lager, Magdalena Beer, and Hammel's Lager Beer. Hammel also had an ice plant in this building. (Courtesy of Socorro County Historical Society.)

The interior of the Illinois Brewing Company is seen here around 1890. Clarence Hammel had installed the compressor and other machinery necessary for the making of ice, as evidenced by the frost on the overhead pipes. (Courtesy of Socorro County Historical Society.)

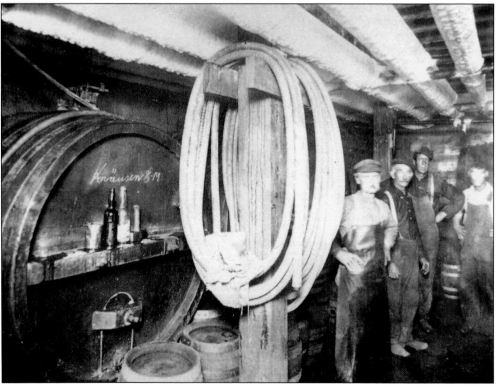

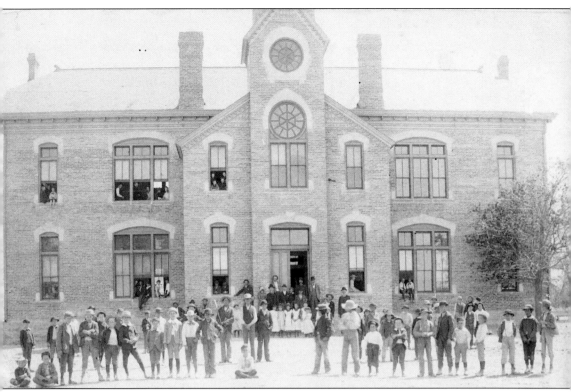

The Socorro Elementary School, shown here around 1910, was built with bricks manufactured in Socorro at the converted Graphic Smelter. The elementary school was commonly referred to as the "Little Red Schoolhouse." The public high school, located next to the elementary school, closed in 1898. The New Mexico School of Mines offered high school classes in its preparatory department until 1913. (Courtesy of Socorro County Historical Society.)

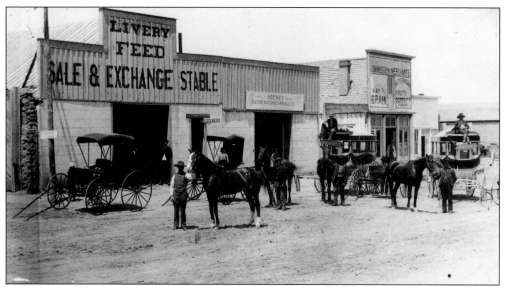

George E. Cook operated the livery stable, shown here in 1886. Residents of Socorro who owned horses could board them, and others could rent horses and buggies on an as-needed basis. Also pictured here are two omnibuses operated by the Socorro Transit Company. The omnibuses were used primarily to transport passengers from the train depot to the various hotels around town. (Courtesy of Suzanne Smith, Joseph E. Smith Collection.)

OUR MOTTO:
"Promptness and Dispatch"

SOCORRO, NEW MEXICO. _____ 191_

M_____

IN ACCOUNT WITH

G. E. COOK

FIRST CLASS CORRAL IN CONNECTION
ALFALFA, HAY, GRAIN, COAL
WOOD, LIME AND CEMENT

Livery, Feed and Sale Stable

CITY FREIGHT AND PASSENGER TRANSFER

The Franklin Press, Pueblo, Colo.

TICKET NO.	DATE	ARTICLES	AMOUNT	CREDIT	TOTAL
	Dee. 20.	To Carfe	35		
		" Dray	10		

This is William Hammel's livery stable bill from Cook's Livery, Feed and Sale Stable, dated January 1, 1912. George E. Cook worked at the St. Louis Smelting & Refining Company in Socorro and opened his livery stable and transfer business in 1905. (Courtesy of Michael Jaramillo.)

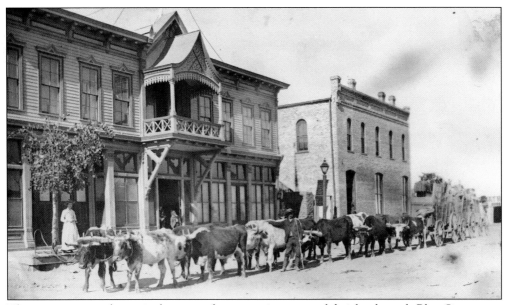

This ox team was the typical means of transporting ore and freight through Blue Canyon, to and from Socorro, Magdalena, and Kelly, prior to completion of the Atchison, Topeka & Santa Fe Railroad spur. This team is pictured in front of the Grand Hotel in 1886. The hotel was located on California Street, south of Manzanares Avenue. (Courtesy of Suzanne Smith, Joseph E. Smith Collection)

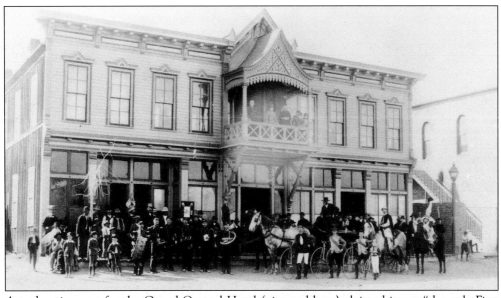

An advertisement for the Grand Central Hotel (pictured here) claimed it was "the only First Class hotel and the pioneer hotel of the Gem City. . . . The table is unsurpassed by any in the whole territory of New Mexico. Free coach to and from all trains. Telephone free for the use of guests." C.H. Saunders was the proprietor. (Courtesy of Socorro County Historical Society, Joseph E. Smith negative no. 495.)

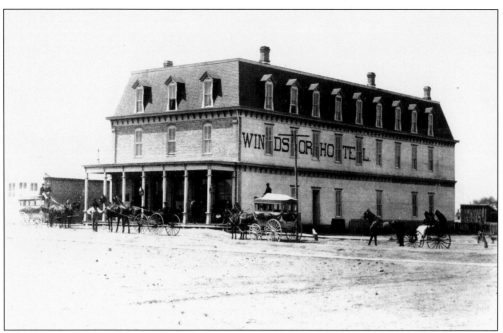

Socorro Transit Company omnibuses are parked in front of the Windsor Hotel. The omnibuses transported visitors from the train depot to the hotel, which was located on the north side of Manzanares Avenue, between Fifth and Sixth Streets. The hotel had a bar and billiard room in addition to the dining room. (Courtesy of Socorro County Historical Society.)

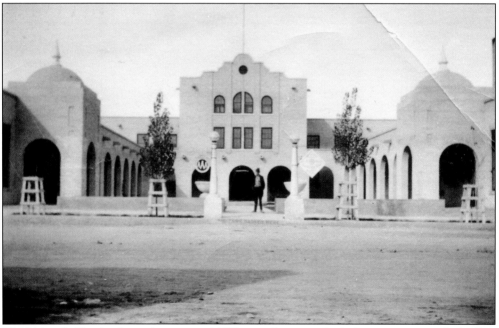

The Valverde Hotel is shown here around 1919, just after it was built. It was constructed of yellow concrete bricks in the Spanish Mission Revival style. The hotel is still located on the north side of Manzanares Avenue, two blocks east of California Street. (Courtesy of Socorro County Historical Society.)

August Winkler stands in front of the Winkler Hotel around 1920. Winkler was a prominent Socorro businessman with hotel, mercantile, and real-estate interests in Socorro and throughout the county. (Courtesy of Socorro County Historical Society.)

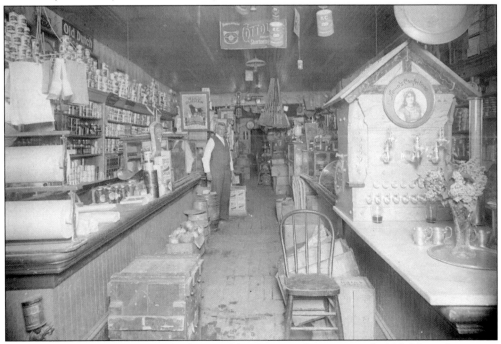

August Winkler is shown inside the Winkler Grocery Store around 1890. Note the ornate carbonated drink dispenser on the counter to the right. This store burned down in 1918. (Courtesy of Socorro County Historical Society.)

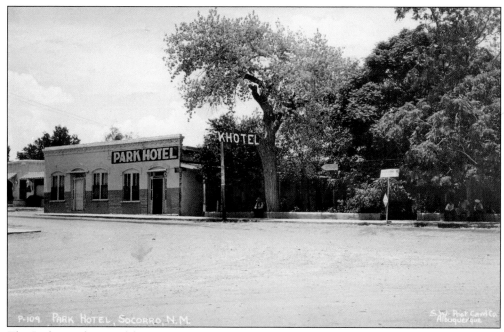

The Park Hotel, named for its proximity to Kittrell Park, was located on the southeast corner of Socorro Plaza, at the corner of Fisher Avenue and Park Street. Pres. Rutherford B. Hayes dined with Gen. William Tecumseh Sherman in the dining room of the Park Hotel in October 1880. (Courtesy of Socorro County Historical Society.)

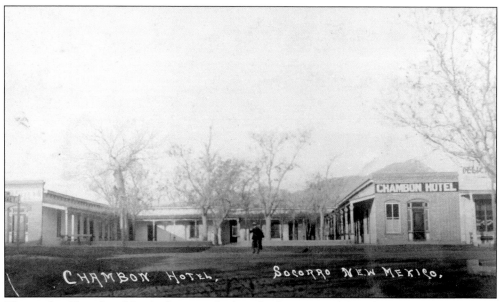

This is the Chambon Hotel, photographed in the late 1910s. The Chambon Hotel became the Park Hotel, at the same location, facing Kittrell Park. (Courtesy of Socorro County Historical Society.)

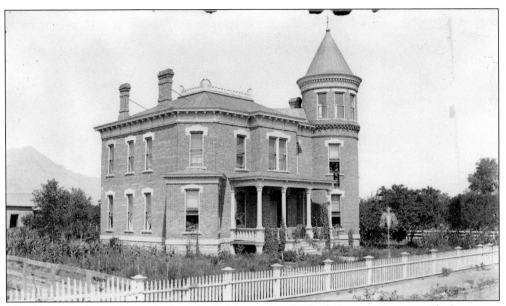

The Abeytia y Armijo house, built in 1885, is located at 407 Park Street in Socorro. The home was named "Casa de Flecha" (house of the arrow) for the distinctive arrow-shaped weather vane on top of the round tower. This two-story Queen Anne brick house is Socorro's most impressive boom-era residence. (Courtesy of Socorro County Historical Society, Joseph E. Smith negative no. 521.)

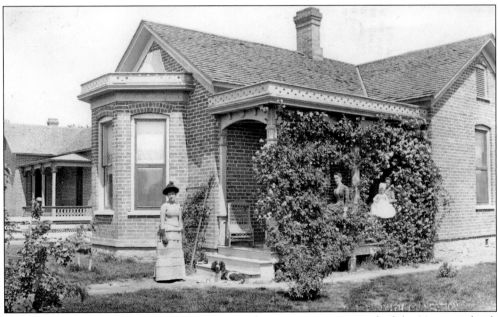

This brick house, which still stands on McCutcheon Avenue, is typical of the Victorian brick houses built by prominent Socorro citizens in the residential areas adjacent to the central plaza and Kittrell Park. The bricks used to construct these houses were manufactured in Socorro. (Courtesy of Suzanne Smith, Joseph E. Smith Collection.)

Holm Olaf Bursum Sr. was born in Fort Dodge, Iowa, in 1867. He came to New Mexico in 1881, seeking a cure for tuberculosis. He served as Socorro County sheriff from 1895 to 1898 and as warden of the New Mexico territorial penitentiary in the early 1900s. In 1921, he was appointed, and was later elected, to the US Senate. (Courtesy of Los Lunas Museum of Heritage and Arts.)

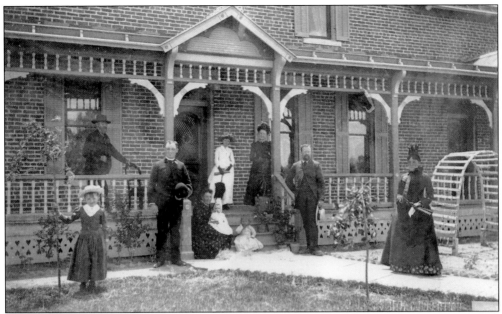

The home of Holm Bursum Sr. (left of center, holding a derby hat) was originally built in 1887 for Candelario Garcia by Socorro builder William Watson. The two-story house is constructed of brick with ornate Victorian gingerbread wood decoration throughout. Both Candelario Garcia and Holm Bursum were important leaders in New Mexico Territorial politics. (Courtesy of Suzanne Smith, Joseph E. Smith Collection.)

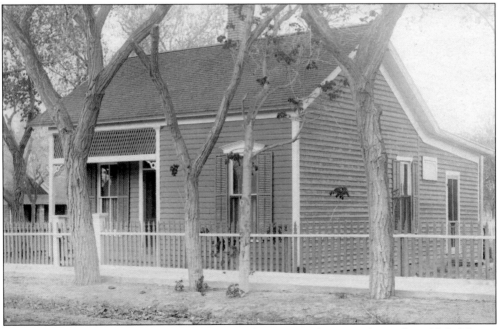

This classic Victorian house, located at 110 Sixth Street, and its twin, located at 407 California Street, were probably ordered from a catalog or pattern book and shipped via the railroad to Socorro in prefabricated sections. It was built in the mid-1890s. This photograph was taken in 1913. (Courtesy of Socorro County Historical Society.)

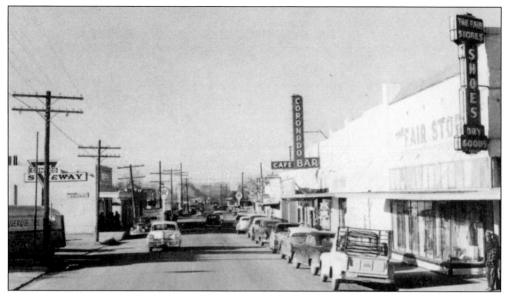

California Street, pictured here in the 1950s, became Socorro's main business route, replacing Manzanares Avenue as the center of commercial activity and tourist travel. The Fair Store and the Coronado Café were located at the intersection of California Street and Manzanares Avenue. (Courtesy of Socorro County Historical Society.)

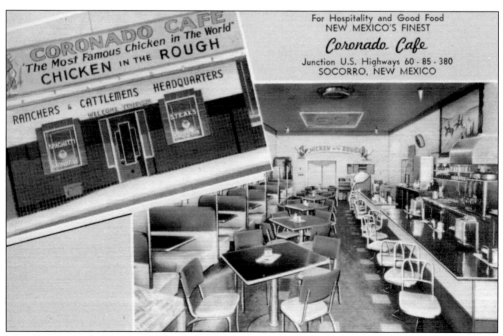

The Coronado Café, operated by Mike Piccinini and Pete and Evelyn Fellis, was a popular bar and restaurant in Socorro. The slogan of the Coronado Café was "Specialties are our specialty." In 1958, the bar and café were leased to Kippie Olguin, who was the manager until 1963, when Earl DeBrine and Raymond Gallegos assumed ownership. (Courtesy of the collection of Bill Hill.)

Two

Joseph E. Smith, Socorro's Pioneer Photographer

Joseph E. Smith (1858–1935), who took many of the photographs in this book, was born in Massachusetts. He studied engineering at the Massachusetts Institute of Technology, and he put this early training to use when he engaged in mining at Kelly, New Mexico. In 1879, he went to Chicago, where he was employed in a photographic shop. His technical training was useful in this endeavor as well.

A boyhood friend of Smith, Edwin A. Bass, had moved to Socorro, New Mexico, and he urged Smith to come as well. When Smith arrived in Socorro, he joined Bass, George Hoyt, and others in establishing ranches located about 60 miles southwest of Socorro. Their attempt at ranching was not successful, and Smith lost about $4,000 in wages and investment funds. He then used his engineering knowledge to engage in mining at Kelly.

Joseph Smith's mining attempts were profitable enough that he was able, in 1884, to purchase the photographic equipment and studio from his friend Edwin Bass, who was engaged to be married and was leaving the West. In 1886, Smith and Marriett Elizabeth Driver were married in Socorro.

From 1886 to 1888, Smith was a cashier at the Atchison, Topeka & Santa Fe Railroad depot in Socorro. From 1888 to 1903, he was the manager of the J.C. Baldridge Lumber and Hardware Company, and from 1903 to 1909, he operated his own drugstore in Socorro. The drugstore was destroyed in a fire in 1908, and from 1909 until his death in 1935, Joseph Smith was active in real estate and insurance.

While he was engaged in these other occupations, Smith continued to operate his photographic studio, taking photographs throughout Socorro and the surrounding area. His life's work, consisting of more than 3,000 glass-plate and film negatives, and the studio where he lived and worked are being preserved and protected by his great-granddaughter Suzanne Smith, who graciously makes these treasures available to the public.

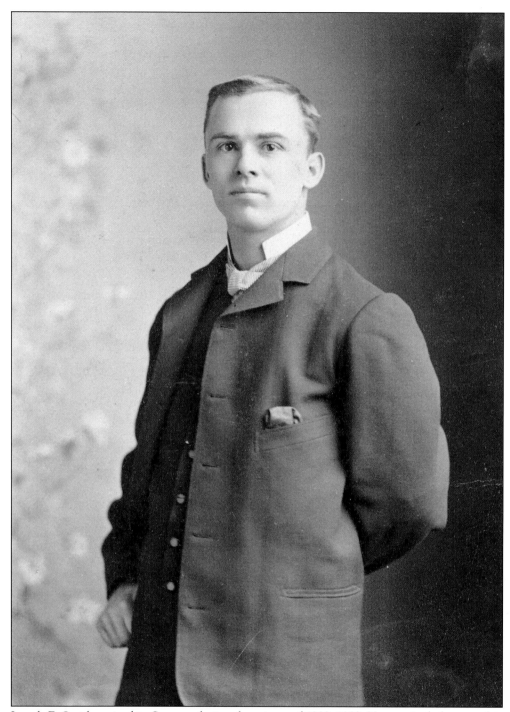

Joseph E. Smith arrived in Socorro during the winter of 1882–1883. He acquired photographic equipment from his friend Edwin A. Bass in 1884 and spent the rest of his life photographing landscapes, cityscapes, and portraits throughout Socorro County. Particularly striking are his early images, made in the 1880s and 1890s, all the more remarkable because of the cumbersome equipment he used. (Courtesy of Suzanne Smith, Joseph E. Smith Collection.)

Edwin Alden Bass was born in 1857 in Massachusetts. A childhood friend of Joseph E. Smith, Bass came to Socorro in 1879 and opened a photographic studio. Smith joined him in 1883, and they were partners in ranching and mining activities in the Magdalena and Kelly areas. Smith eventually purchased the Bass photographic business and operated it until 1889. (Courtesy of Suzanne Smith, Joseph E. Smith Collection.)

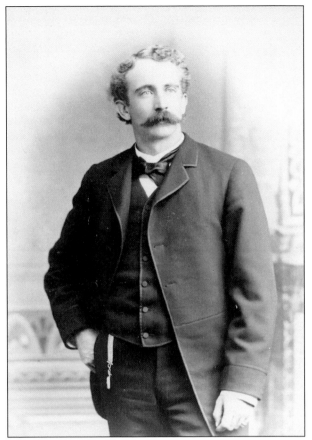

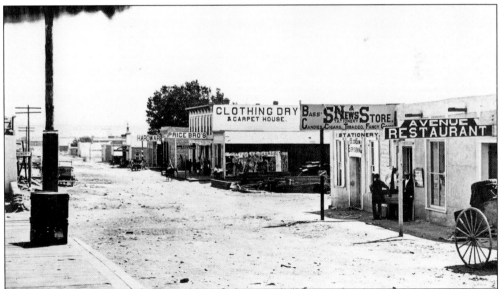

On the right in this photograph is Edwin A. Bass's notions store. Farther down the street, in the same building as Price's dry goods store, is Bass's photographic studio. Joseph E. Smith worked with Bass in both of these establishments. (Courtesy of Suzanne Smith, Joseph E. Smith Collection.)

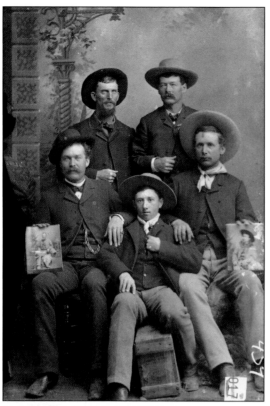

In addition to making portraits of almost everyone in town, Smith roamed the countryside, taking photographs of mines, ranches, the railroad, city streets, merchant buildings, schools, churches, landscapes, and other interesting subjects. More than 3,000 of Joseph E. Smith's negatives are preserved by his great-granddaughter Suzanne Smith. (Courtesy of Suzanne Smith, Joseph E. Smith Collection.)

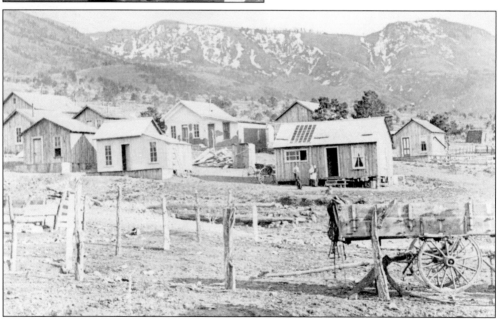

In 1885 and 1886, Joseph E. Smith lived in Kelly, where he pursued his mining interests, a natural outgrowth of his engineering background. He also worked as a photographer, evidenced by the large skylight in the roof of his house, which provided the best light for portraits. This photograph was taken in 1886. (Courtesy of Socorro County Historical Society.)

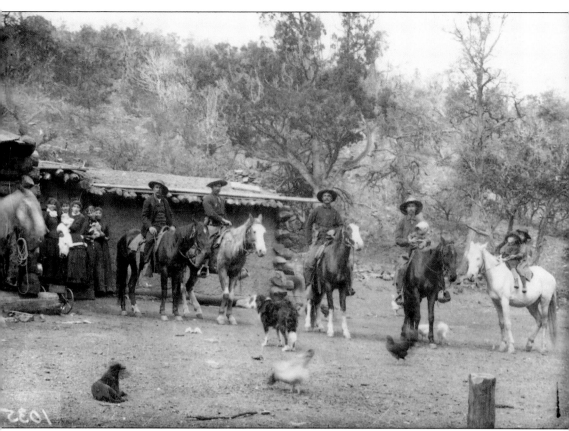

In addition to being a first-rate professional photographer, Joseph E. Smith, pictured here on horseback, second from the left, was also a rancher and miner. He was a partner with his friend Edwin A. Bass and George Hoyt in a ranch they named Snake Ranch, located south of Magdalena in the San Mateo Mountains. The partners also developed mining claims together near Kelly. (Courtesy of Suzanne Smith, Joseph E. Smith Collection.)

Joseph E. Smith married Marriett Elizabeth "Myscie" (pronounced Missie) Driver, from Darlington, Wisconsin, in 1886. She accompanied him on most of his photographic excursions and was an active partner in his business. They had five children: Marvel Martin, James Avery, Irene Juanita, Irving Lee, and Josephine, who died in infancy. (Courtesy of Suzanne Smith, Joseph E. Smith Collection.)

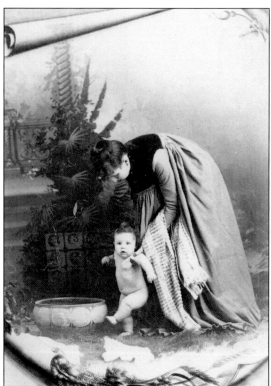

Joseph E. Smith took this photograph of his wife, Myscie, and their son Marvel Martin Smith, when Marvel was six months old. (Courtesy of Suzanne Smith, Joseph E. Smith Collection.)

Joseph Smith took this photograph of his son Avery around 1890. Smith photographed throughout the Socorro County area, including Socorro, Kelly, Magdalena, San Antonio, and San Marcial. He photographed landscapes, mining activities, street scenes, and public events, but his specialty was portraiture. His skill in capturing a special feeling is evident here. (Courtesy Suzanne Smith, Joseph E. Smith Collection.)

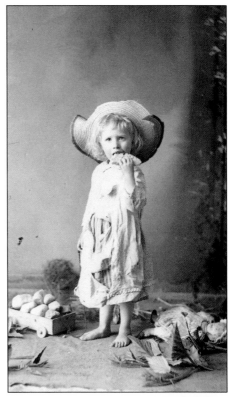

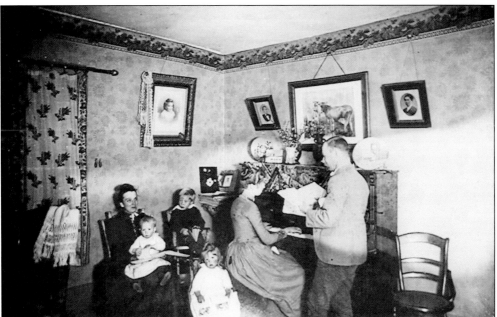

Joseph Smith (right) is seen here in the parlor of the Smith home on Central Avenue in Socorro. Myscie Smith is at the piano. Myscie's cousin is seated at left. Joseph Smith's great-granddaughter, Suzanne Smith, still lives in this house. She is preserving it as a museum honoring her great-grandfather's work. (Courtesy of Suzanne Smith, Joseph E. Smith Collection.)

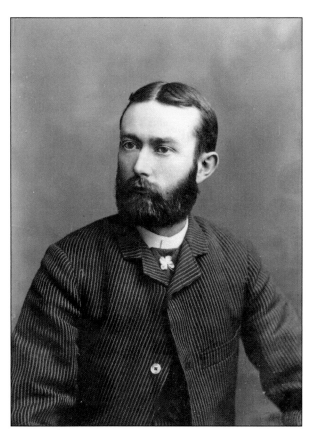

James Leighton was Myscie Smith's cousin from Wisconsin. He came to Kelly shortly after Joseph E. Smith arrived there, joining with Smith in mining and ranching activities. Smith took this portrait of his cousin at his studio in Socorro around 1884. (Courtesy of Suzanne Smith, Joseph E. Smith Collection.)

Socorro photographer Joseph E. Smith sought to honor the Pueblo/Spanish architectural heritage when he remodeled the old McCutcheon house on Park Street near the plaza. It was Smith who added the round ends to the two front wings of the building. They were meant to resemble Spanish fortresses called *torreones*. Because of these features, the property was commonly referred to as El Torreon. (Courtesy of Suzanne Smith, Joseph E. Smith Collection.)

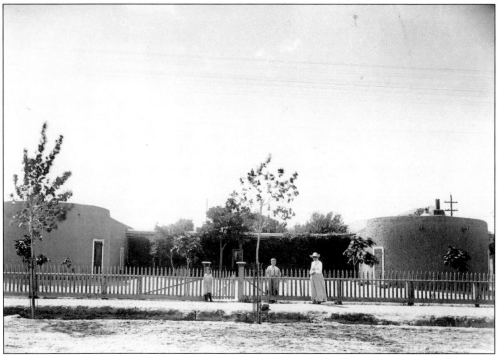

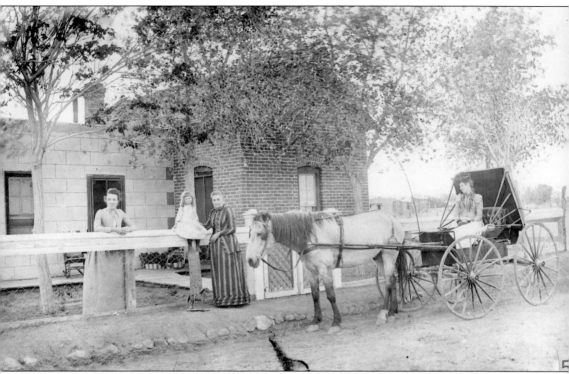

Members of Joseph E. Smith's family are shown here in front of the Smith home on Central Avenue around 1890. Posing here are, from left to right, Mary Jackson, Joseph Smith's aunt; Marvel Smith, his son; Nancy Collins Smith, Joseph Smith's mother; and, in the buggy, Myscie Smith, Joseph Smith's wife. This house is currently occupied by Suzanne Smith, Joseph Smith's great-granddaughter. (Courtesy of Suzanne Smith, Joseph E. Smith Collection.)

Last Chance !

—— TO HAVE ——

Your Photograph Taken

————

August will be the last month I shall remain in Socorro to do

PHOTOGRAPH

Work. The 1st of September I shall close PERMANENTLY my Photograph Gallery in Socorro, and ship instruments and apparatus East. Therefore, I invite all who desire Photographs of themselves, family or friends, copies of old and fading pictures, enlargements in

Crayon, India Ink, Water Colors, Etc.,

Frames, or any work in my line, to call immediately.

Do not wait until the 31st of August before you come, for I cannot attend to you all then, and I state positively that on September 1, 1889, I shall close my Photograph business in Socorro.

I have in my possession about 5,000 negatives made by Bass, Loomis & Co., and myself —negatives made since '79 up to date. I will take orders for Photographs from these negatives

At One-Half Regular Price,

Or sell you the negative, from which you can have Photos made at any time by any photographer. Give this your immediate attention, or you may be sorry when it is too late, or you get sick, that you did not have your picture taken by

J. E. SMITH,

Photographer, Socorro, N, M.

GALLERY CLOSED UNTIL AUGUST 1ST.

Joseph E. Smith purchased the photography studio of his childhood friend Edwin A. Bass in 1884. With this purchase, he obtained the negatives of photographs by Bass and those belonging to Loomis and Company, dating to 1879. Although he closed his photography business in 1889, Smith continued to take professional-quality photographs in Socorro and the surrounding area until his death in 1935. (Courtesy of Suzanne Smith, Joseph E. Smith Collection.)

Three

FARMING AND RANCHING

Agriculture in the Socorro area began with Native American people cultivating corn, beans, and squash, using primitive irrigation systems that were fed by water from the Rio Grande. The same crops that the Indians raised were also raised by Spanish settlers, who introduced horses, cattle, and sheep, cereal grains like wheat and rye, fruit trees, vineyards, and chile.

The Spaniards also developed the sophisticated *acequia madre* system of irrigation ditches and laterals that became the lifeblood of agriculture in the Socorro area. With the arrival of the railroad in Socorro, agricultural products could be shipped to markets in Chicago, St. Louis, Denver, and Los Angeles. The ice plant that Clarence Hammel built as part of the Illinois Brewing Company provided ice that was used to refrigerate the train cars filled with produce. "Icing the train" was an important activity, and it could occupy as many as 100 men.

The orchard and vineyard owned by W.H. Byerts was the most extensive in the area, with 100,000 fruit trees and 2,000 to 3,000 grapevines.

From the time of the earliest Spanish settlers, until shortly after the end of the Civil War, sheep raising was the dominant livestock business. In the 1870s and 1880s, beef was favored more than mutton, and cotton rivaled wool in cloth production, making sheep raising less economically feasible than cattle raising.

The combination of rising cattle prices and the building of a railroad spur from Magdalena to Socorro provided the rationale for creating a large stock pen there. Cattle were driven on the Magdalena Driveway from as far as 90 miles west, in eastern Arizona, and from ranches throughout western New Mexico, to the stock pens in Magdalena. From there, the cattle were shipped to Socorro, then to markets in the Midwest and East. The Magdalena Driveway was active until the 1970s, when most cattle were transported to market by trucks.

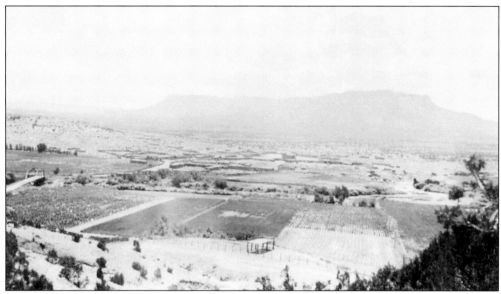

A series of irrigation ditches, or *acequias*, carried water from the Rio Grande to the fields planted around the Socorro area. The fields pictured here were located north of Socorro, near San Acacia. Alfalfa, wheat, corn, and beans were among the crops grown. The coming of the railroad in the 1880s opened up new markets for agricultural products from Socorro and surrounding communities. (Courtesy of Socorro County Historical Society.)

Ethan Eaton is shown here with his wife, Marcellina Chavez Eaton, shortly before his death in 1916. The couple was married in Santa Fe, New Mexico, in 1850. In an ironic twist, Ethan Eaton, a Civil War veteran, pioneer rancher, and miner, died, as the *Socorro Chieftain* reported, "as a result of injuries sustained by being drawn into a gasoline engine." (Courtesy of Socorro County Historical Society.)

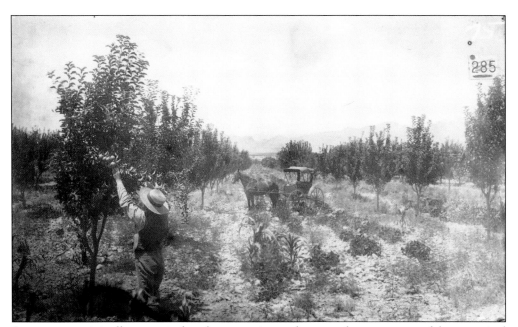

Socorro was originally an agricultural community, and among the most successful crops raised were orchards of fruit. Water from the springs at Socorro Peak, fertile valley soil, and irrigation ditches fed by the Rio Grande were all factors that favored agriculture. Pictured here is the orchard of Abraham D. Coon. (Courtesy of Suzanne Smith, Joseph E. Smith Collection.)

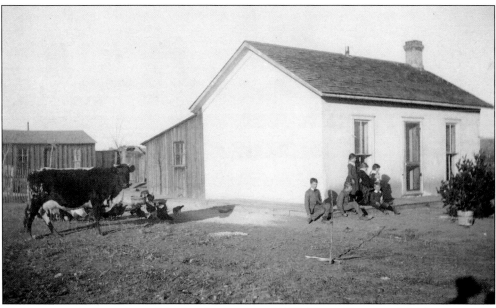

Children pose in front of an adobe farmhouse around 1882. The milk cow and chickens provided milk and eggs for the family, and they were usually tended to by the children. Note that the children are dressed in their finest clothes for the photographer, Edwin A. Bass. (Courtesy of Socorro County Historical Society.)

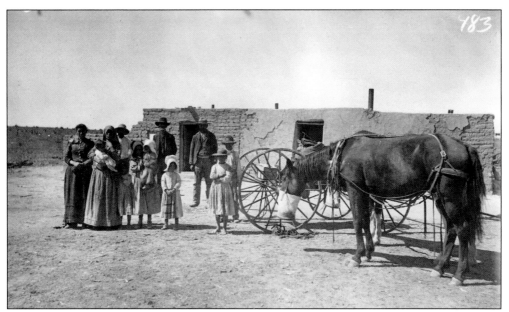

This is a typical farm homestead, seen around 1885, located just south of Socorro. The house is constructed of adobe bricks, made on-site by this family. The one-story, flat roof design is common, and additions were made as the family grew. This family was modestly prosperous, as shown by the two horses, which were intentionally included in the photograph. (Courtesy of Suzanne Smith, Joseph E. Smith Collection.)

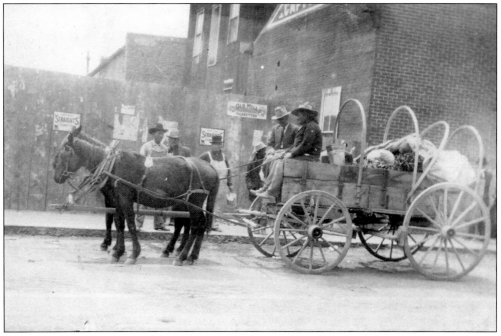

When the railroad arrived in Socorro, the market for agricultural products from throughout Socorro County was greatly expanded. For the first time, farmers could raise more crops than could be consumed by the local economy and ship the excess goods to larger markets. This wagon, seen here around 1920, is loaded with green chile. (Courtesy Socorro County Historical Society.)

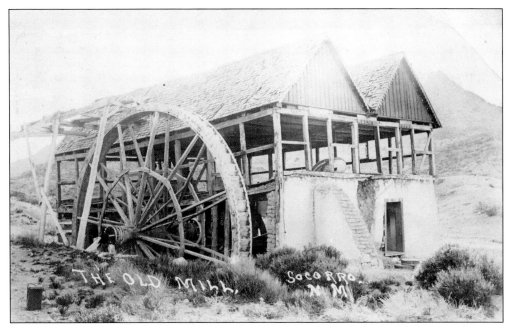

Manuel Vigil built a flour mill powered by water from the Vigil Spring in the 1850s. In the mid-1870s, Samuel Zimmerly and his wife, Maria Pablita Torres, built the mill pictured here at the site of the old Vigil mill. Samuel died in 1888, and his widow and their son Juan continued to operate the mill until 1913. (Courtesy of Socorro County Historical Society.)

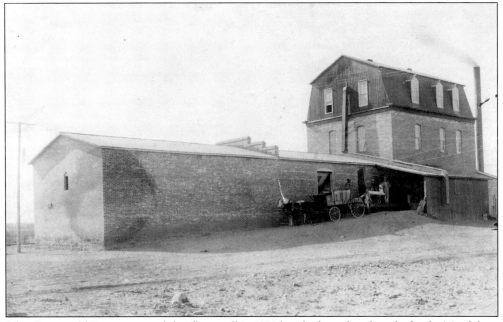

John Greenwald Sr. constructed this flour mill in 1892 beside the railroad tracks for the Magdalena spur. Built originally as a one-story building, the mill was expanded in 1899 to three stories. Power to turn the new motorized metal grinders was provided by a steam boiler, eliminating the dependence on spring-fed water wheels. This photograph was taken in 1903. (Courtesy of Socorro County Historical Society.)

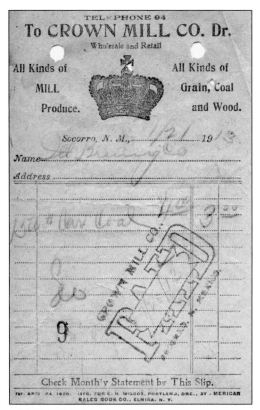

In addition to flour, the Crown Mill also sold coal and wood. This sales ticket for coal sold to the Illinois Brewing Company, operated by Clarence Hammel, is dated January 21, 1913. During peak production, the Crown Mill turned out 10,000 pounds of flour per day. (Courtesy of Michael Jaramillo.)

This photograph of the interior of the Crown Mill was taken in 1903. Shown here are, from left to right, John Greenwald Sr., his son Joseph Greenwald, and mill workers Carlos Salas and Pedro Torres. John Sr. and Joseph both died in 1923. John Greenwald Jr. operated the mill from 1923 until his death in 1965. (Courtesy of Socorro County Historical Society.)

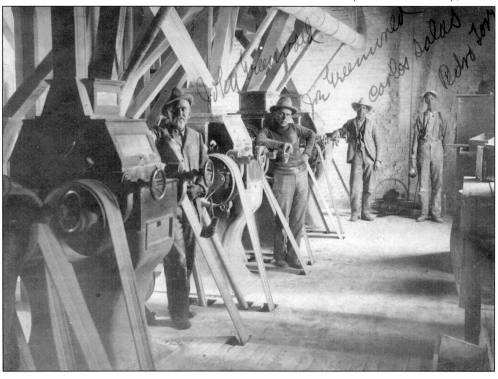

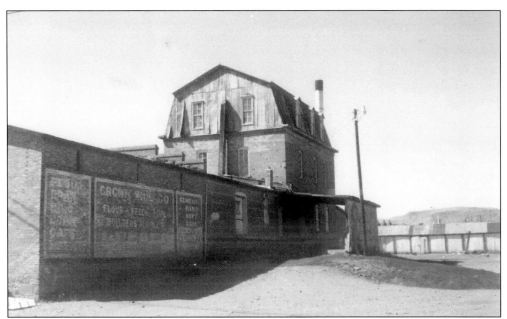

When John Greenwald Jr. died in 1965, the Crown Mill, renamed the Golden Crown Mill, was purchased by Art Murphy, who used the building for his woodworking business. He only used the first-floor space. In 2003, Edward and Martha Savedra purchased the structure and completely rebuilt the third-story walls and roof, protecting the structure from further damage. (Courtesy of Socorro County Historical Society.)

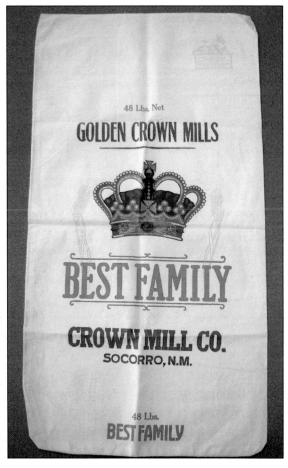

In 2011, Patrick and Terry Graves, great-grandsons of John Greenwald Sr., presented the Socorro County Historical Society with an unused flour sack from the Golden Crown Mill. The mill often operated around the clock to satisfy the demand for flour, and Crown Mill flour was shipped all over the United States. (Courtesy of Socorro County Historical Society.)

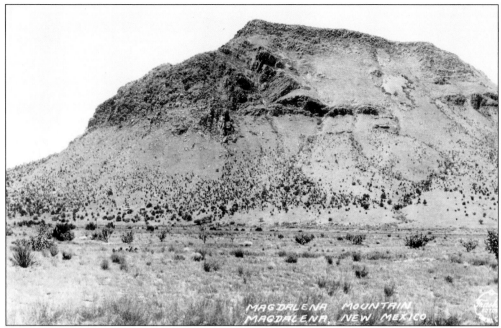

Magdalena Mountain is the highest peak in the Magdalena Mountain chain. It was named for a talus and shrub-growth formation on the east side of the mountain that is said to resemble a woman's face. Legend holds that a group of farmers were being attacked by Indians when the image of Mary Magdalene appeared on the side of the mountain, frightening the Indians away. Edwin A. Bass took this photograph. (Courtesy of Socorro County Historical Society.)

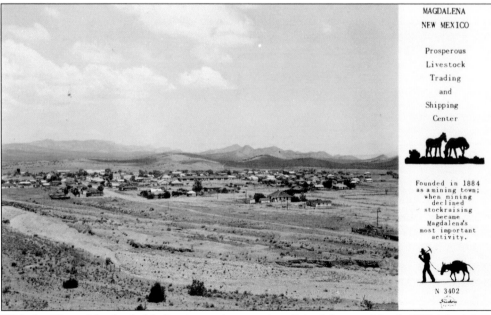

With the filing of the deed of dedication to the townsite of Magdalena on May 8, 1884, Magdalena officially became a town. Magdalena was founded as a mining community, but when mining declined, livestock shipping and trading became the town's most important activity. (Courtesy of Socorro County Historical Society.)

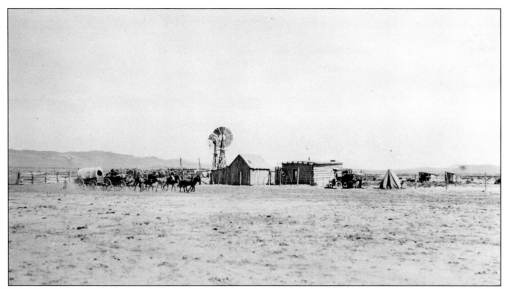

Ranching was important to the economy of Socorro. This well-laid-out ranch, photographed around 1920, includes cattle pens, two windmills, and outbuildings constructed of logs. The six-horse team is pulling two wagons. Horses were not the only means of transportation, however. Note the Model-T automobile next to the log building. (Courtesy of Socorro County Historical Society.)

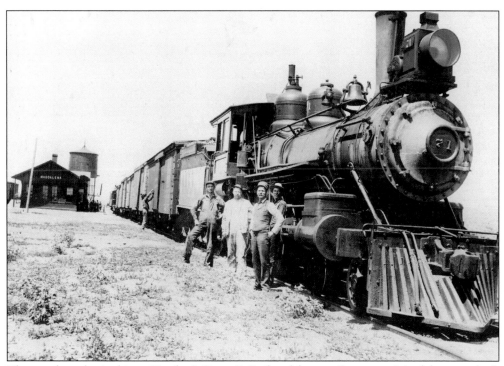

The spur from the Atchison, Topeka & Santa Fe Railroad depot at Socorro, to Magdalena, was built in 1885. The train not only served to haul ore from the mines at Kelly and the Magdalena Mountains to the smelters in Socorro, but also brought cattle from the Magdalena Driveway to Socorro for shipment to eastern markets. (Courtesy of Suzanne Smith, Joseph E. Smith Collection.)

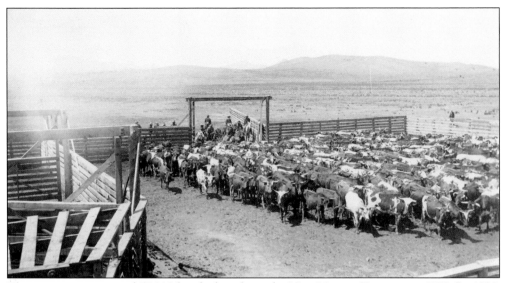

There were an estimated 57,000 head of cattle in the New Mexico Territory in 1870. By 1880, there were almost 350,000 cattle. A growing population, multiple mining camps, government forts, and the Indian tribes under the control of those forts all fueled the dramatic increase in the cattle market. (Courtesy of Suzanne Smith, Joseph E. Smith Collection.)

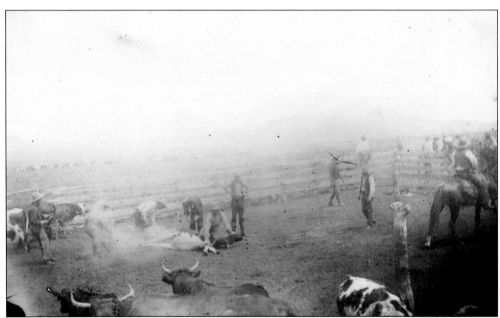

The railroad reached Magdalena in January 1885. Stock pens were built in Magdalena to hold cattle and sheep prior to being loaded on railroad cars for shipment to eastern markets. The stock pens were also used for branding, as seen here around 1890. (Courtesy of Suzanne Smith, Joseph E. Smith Collection.)

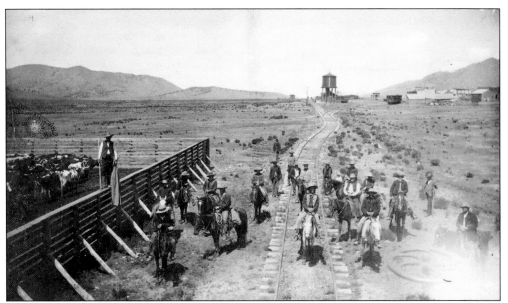

In addition to hauling ore from the mines, the Socorro-Magdalena railroad spur allowed Magdalena to become an important cattle-shipping location for central and southwestern New Mexico and eastern Arizona. Extensive stockyards were constructed next to the railroad tracks. Cowboys looked forward to unwinding from the trail drives in the town of Magdalena. (Courtesy of Suzanne Smith, Joseph E. Smith Collection.)

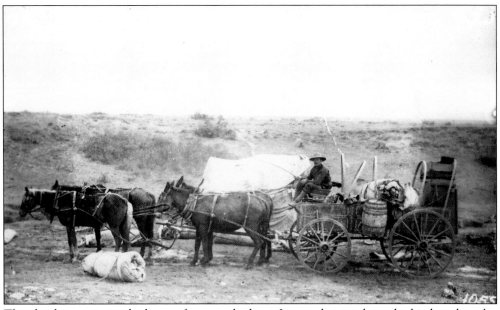

The chuck wagon was the heart of any cattle drive. It served not only as the kitchen, but also as the medical center, water supply, and bedroll storage locker for the trail crew. Overseeing all of this was the cook, who consistently served up meals that were remarkably tasty. Bad cooks were generally not tolerated on a trail drive. This chuck wagon was photographed around 1885. (Courtesy of Suzanne Smith, Joseph E. Smith Collection.)

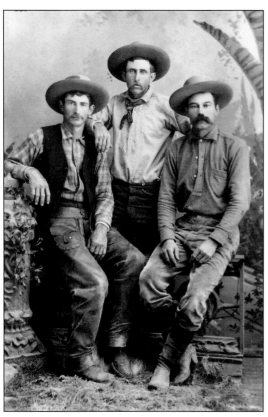

Most cowboys who drove herds of cattle on the Magdalena Driveway owned only the clothes on their back, perhaps a sidearm, and a saddle. They generally did not own their horse. These unidentified cowboys pose for Joseph E. Smith in his Socorro studio around 1887. (Courtesy of Suzanne Smith, Joseph E. Smith Collection.)

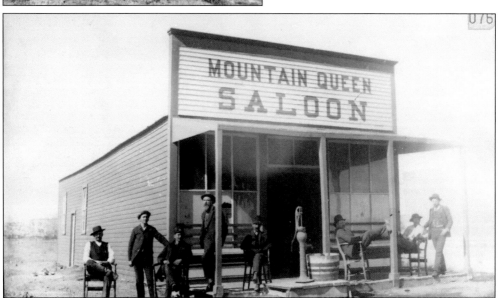

Cowboys were paid at the end of the trail drive. The town of Magdalena offered hotels where the cowboys could eat their meals and sleep, mercantile stores where they could replace the clothing they had worn out on the drive, and saloons where they could get a drink and find a poker game. When the money was gone, the cowboy would sign up for another trail drive. (Courtesy of Suzanne Smith, Joseph E. Smith Collection.)

Many of the cowboys who drove cattle on the Magdalena Driveway had their portraits taken by Joseph E. Smith at his Socorro studio. They dressed in their finest and often played a "role" for the camera. These cowboys are shown in a common pose called "poker draw." (Courtesy of Suzanne Smith, Joseph E. Smith Collection.)

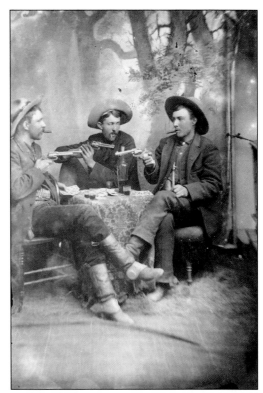

Malcolm "Buddy" Major was born in Socorro in 1921. From the 1950s to the 1970s, he bought and sold cattle in Magdalena and led one of the last cattle drives on the Magdalena Driveway. Buddy Major served on the Magdalena School Board, the New Mexico State Fair Board, and was a Socorro County commissioner. He is shown here about 1970 with his wife, Helen Hobbs Major. (Courtesy of Los Lunas Museum of Heritage and Arts.)

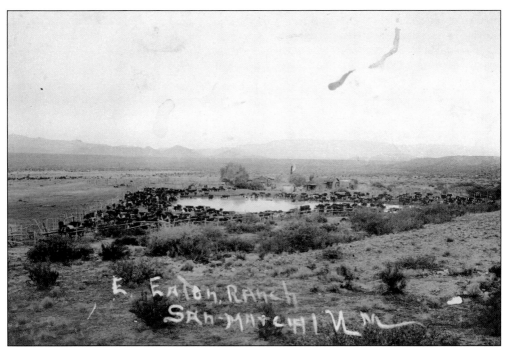

Cattle ranches were centered on springs and water tanks. Control of the water meant control of thousands of acres of land for grazing cattle and sheep. The ranch pictured here around 1890, owned by Ethan W. Eaton, was located near San Marcial. (Courtesy of Suzanne Smith, Joseph E. Smith Collection.)

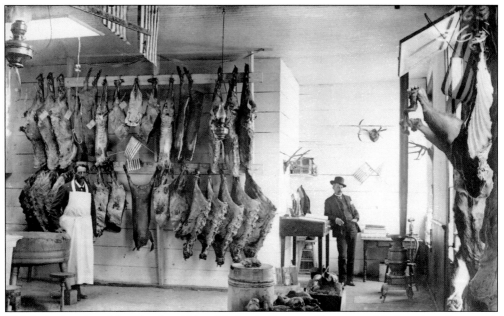

This is the interior of the Blanchard Meat Market in Socorro. Carcasses with American flags stuck in them had been sold to the government and were destined for Fort Craig, about 25 miles south of Socorro, or for Indian agencies for distribution to Native Americans on nearby reservations. (Courtesy of Suzanne Smith, Joseph E. Smith Collection.)

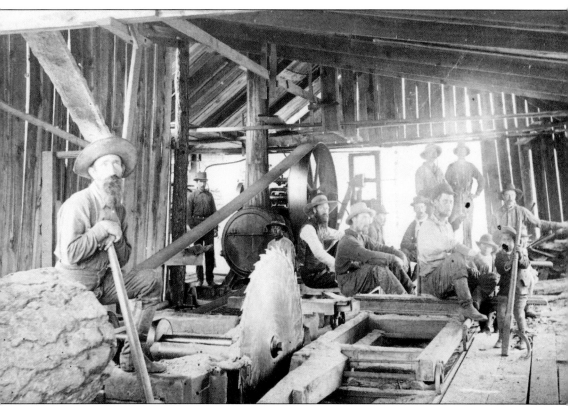

The demand for lumber created by new towns like Magdalena and Kelly and by the dramatic growth of Socorro as a commercial center was filled by numerous sawmills throughout the area. The sawmill pictured here around 1885 was owned by Montague Stevens. (Courtesy of Socorro County Historical Society.)

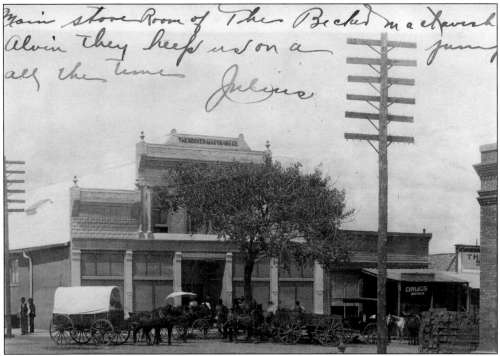

John Sinclair Mactavish arrived in Magdalena in 1897 and was employed as manager of the Becker-Blackwell Company, cofounded by Gustav Becker, brother of Belen, New Mexico, merchant John Becker. Mactavish later became a partner in the company, and the name was changed to the Becker-Mactavish Company. Here, employees stand in front of the store in 1913. (Courtesy of the Collection of Bill Hill.)

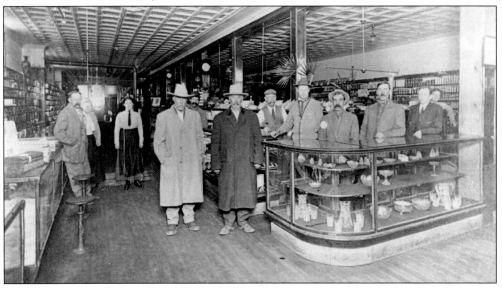

The interior of the Becker Mactavish store in Magdalena is seen here around 1920. At one time, the Bank of Magdalena was located in this store, before the New Mexico Territorial legislature passed a law that prohibited the providing of banking services inside mercantile establishments. (Courtesy of Socorro County Historical Society.)

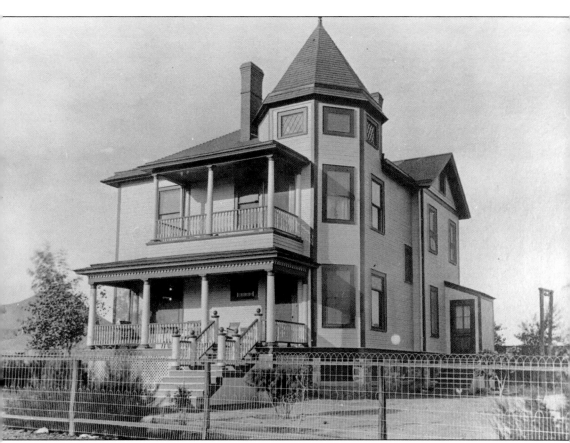

John Mactavish built this three-story house in Magdalena around 1907. The house, still used as a residence today, is one of Magdalena's most distinctive homes. Mactavish was born in Scotland in 1867 and came to America in 1887. He settled in Albuquerque, New Mexico, and worked for several years as a clerk for Gross, Blackwell & Company. He came to Magdalena in 1895. (Courtesy of Socorro County Historical Society.)

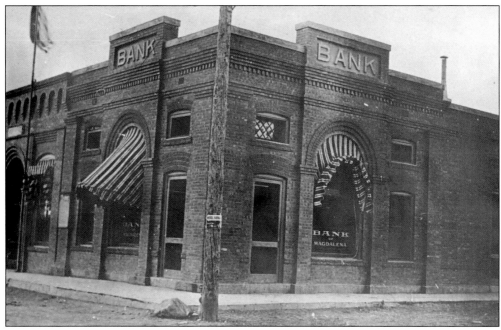

The first bank in Magdalena was located inside the Becker Mactavish store. The New Mexico Territorial Legislature passed a law prohibiting banking facilities in commercial stores, so a bank was established in this building. The original organizers were John S. Mactavish, Oscar Redman, Anastacio Baca, John Becker, Gustav Becker, Joshua Reynolds, and Abb Alexander. (Courtesy of Socorro County Historical Society.)

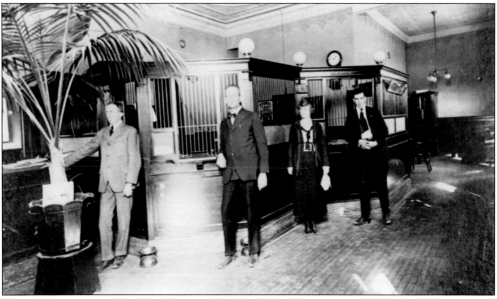

This is the interior of the First National Bank of Magdalena, around 1920. In 1921, an armed gunman robbed the bank of $800. A posse was formed and captured the robber, who was hiding in the stockyards. Milt Craig, who ran the Ford garage in Magdalena, is credited with capturing the bandit and bringing him and the money back to town. (Courtesy of Socorro County Historical Society.)

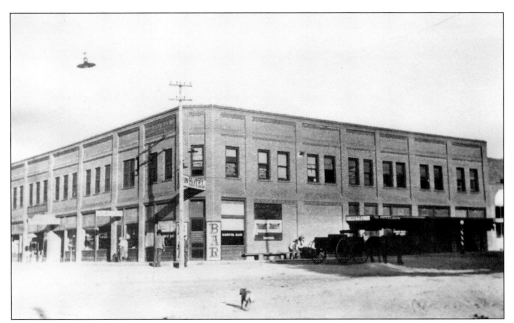

This photograph of the main business block in Magdalena was taken in 1920. By 1941, Magdalena listed among its businesses an electric co-op, two automobile dealers, two drugstores, three mercantile businesses, a dry cleaner, an optician, a bakery, and several service stations. Only two bars were listed, however. (Courtesy of Socorro County Historical Society.)

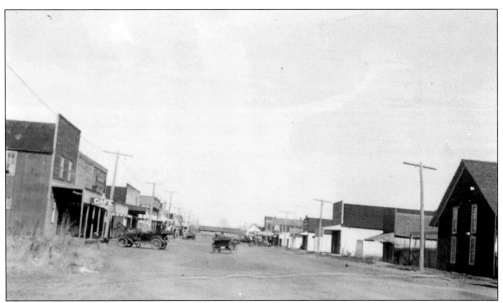

By January 1886, Magdalena had a drugstore, notions store, hardware store, sash-and-door establishment, bookstore, feed store, a church, schoolhouse, two general stores, two livery stables, two blacksmith shops, two lumberyards, three restaurants, and four saloons. As in most frontier towns, saloons outnumbered churches or schools. (Courtesy of Socorro County Historical Society.)

Saint Mary Magdalene Catholic Church in Magdalena was planned during boom times in the 1890s as a two-story church with a basement. Only the basement had been dug when hard times hit the town, so parishioners simply roofed the basement. Immediately behind the front doors, stairs lead down into the sanctuary. (Author's collection.)

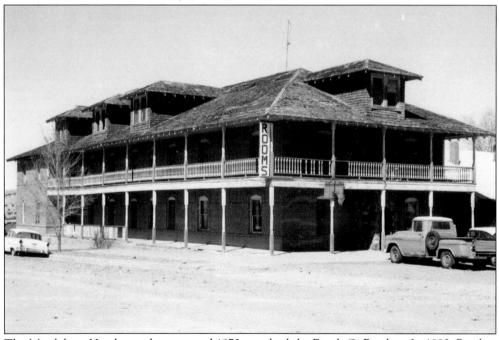

The Magdalena Hotel, seen here around 1970, was built by Frank G. Bartlett. In 1883, Bartlett established the first business and erected the first building in Magdalena. In addition to the hotel, he had a sawmill, raised sheep and cattle, and operated a general mercantile. (Courtesy of Socorro County Historical Society.)

Four

MINING BRINGS
BOOM TIMES

The success and dramatic growth of mining activity in the Socorro, Magdalena, and Kelly areas was due largely to the efforts of two men. Col. J.S. "Old Hutch" Hutchason was the first to discover the rich silver and lead carbonate deposits in the Magdalena Mountains. The second major contributor to the area's boom times was Gustav Billing, who had the financial resources to establish a smelting operation, able to efficiently and profitably process ore from the mines.

"Old Hutch" attempted to develop the mine potential on his own, but the real surge in mining activity came when he sold his interests to several other men interested in investing in mining. He sold one-half of the Juanita Mine to Thomas B. Catron, and the other half to Ethan W. Eaton, in 1875. Ethan Eaton also purchased the Graphic Mine, and Patrick Dorsey bought the Kelly Mine. However, without the smelting capability to reduce the bulky ore to a more commercial commodity, the increased production would have no market.

On September 1, 1883, the *Bullion* newspaper reported: "Mr. Billing came to Socorro during her darkest days . . . saw the large amount of . . . ore . . . available in the Magdalena Mountains . . . and at once perceived the advantages of the place." Gustav Billing recognized that Socorro's location on the Atchison, Topeka & Santa Fe Railroad line, and the presence of abundant water from Socorro Springs, favored the building of a smelting facility in the town.

The Billing Smelter was located about two miles from the Socorro Plaza, at a place that came to be called Park City. The smelter was in operation by January 1884. Each day, 100 tons of ore from the Kelly mines was delivered to the smelter in Park City. Ox and mule teams pulled wagons loaded with 5,000–7,000 pounds of ore. The smelter furnaces were fueled by coking coal from Carthage, located east of San Antonio.

The full potential of the mining resources of the area was finally realized when a railroad spur was constructed from Magdalena to Socorro, replacing the ox and mule wagon route through Blue Canyon.

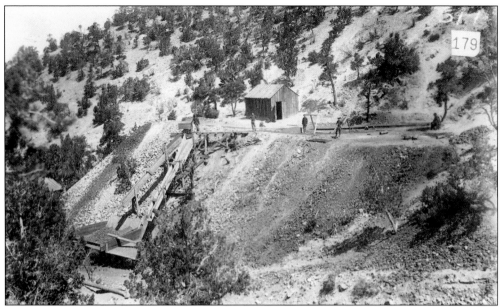

J.S. Hutchason, known as "Old Hutch," discovered the rich mineral deposits in the Magdalena Mountains in the spring of 1866. He first staked a claim to the Juanita Mine and, three weeks later, staked the Graphic Mine (pictured). Hutchason sold the Graphic Mine in the late 1870s for $30,000. (Courtesy of Suzanne Smith, Joseph E. Smith Collection.)

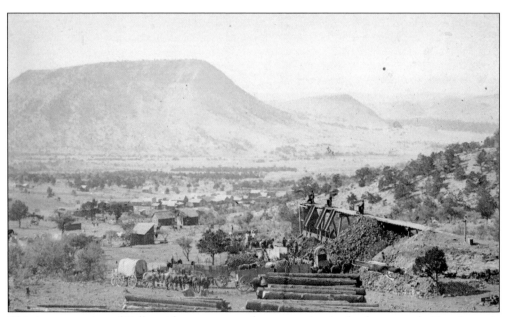

This is an overview of Kelly, with teamsters and construction in the foreground. Also shown is the loading of ore at the Kelly Mine dump. Edwin A. Bass took this photograph sometime around 1880. (Courtesy of Socorro County Historical Society.)

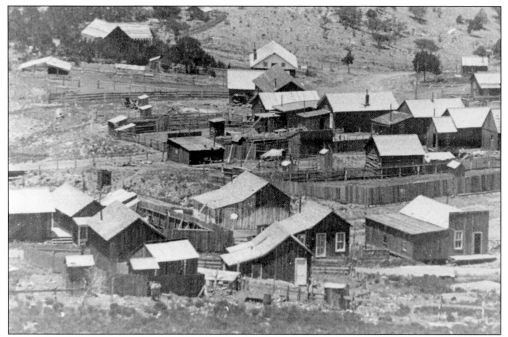

Mining activity began in Kelly in 1881, when Gustav Billing acquired the Kelly Mine for $45,000 and developed it to its fullest potential. The mine remained in the Billing family until 1904, when Gustav's widow, Henriette, sold it to the Tri-Bullion Mining and Smelting Company. (Courtesy of Socorro County Historical Society.)

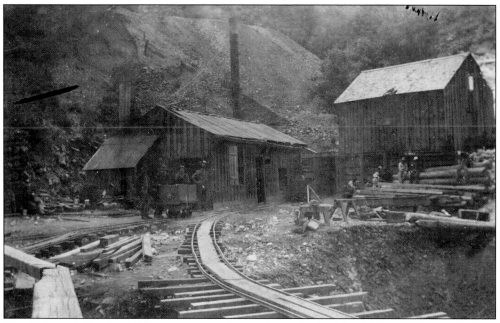

The Kelly and Graphic Mines were the major producers in the Magdalena district, accounting for nearly 90 percent of the $9 million yield produced before 1890. The Juanita Mine was next in productivity, followed by a number of lesser mines and claims. Pictured here is the Graphic Mine. (Courtesy of Socorro County Historical Society.)

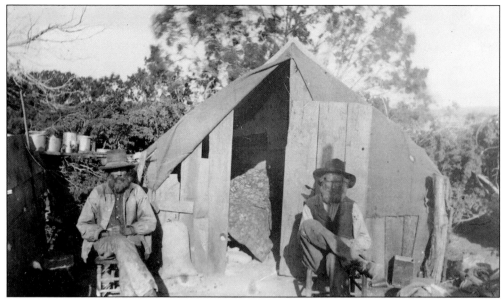

These miners, pictured at their camp near Kelly around 1880, are typical of those who sought their fortunes during Socorro's boom times. Mining activity in the Socorro and Magdalena Mountains drew prospectors who located and filed claims on ore deposits and miners who worked those claims. (Courtesy of Suzanne Smith, Joseph E. Smith Collection.)

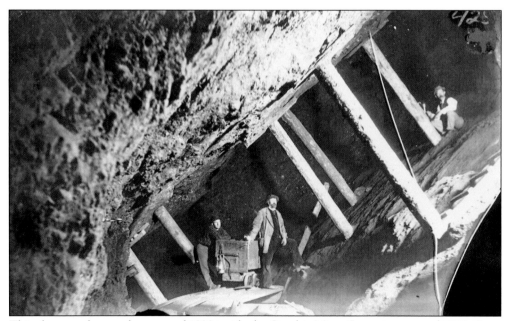

This photograph was taken around 1890 inside the Graphic Mine. Sometime around 1900, Cony T. Brown had some samples from the waste dump piles at the Graphic Mine tested. The mineral turned out to be a carbonate of zinc called smithsonite. In 1904, Brown and his partner, J.B. Fitch, sold the Graphic Mine to the Sherwin Williams Paint Company. The smithsonite deposits were exhausted by 1931. (Courtesy of Suzanne Smith, Joseph E. Smith Collection.)

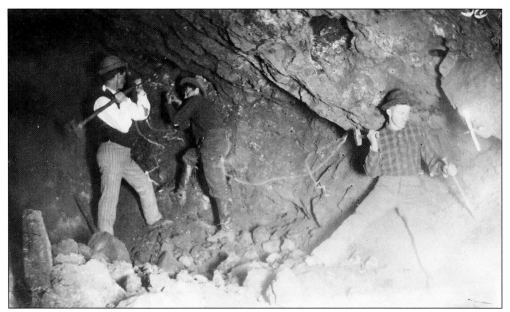

This posed photograph, taken inside the Graphic Mine by Joseph E. Smith in the 1880s, gives a sense of just how difficult it was for hardscrabble miners to extract mineral wealth from the earth. The two miners on the left are called "double jackers," and the one on the right is a "single jacker." The handheld star drill was given a quarter turn after each hammer blow. (Courtesy of Suzanne Smith, Joseph E. Smith Collection.)

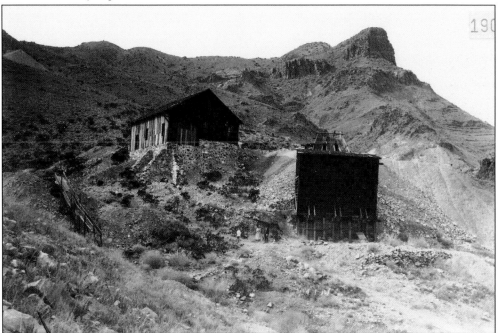

The Torrance Mine, pictured here around 1886, along with the Merritt Mine, were the two highest-producing mines in the Magdalena-Socorro mining district. The wooden building is a boardinghouse for the men who worked in the mine. (Courtesy of Suzanne Smith, Joseph E. Smith Collection.)

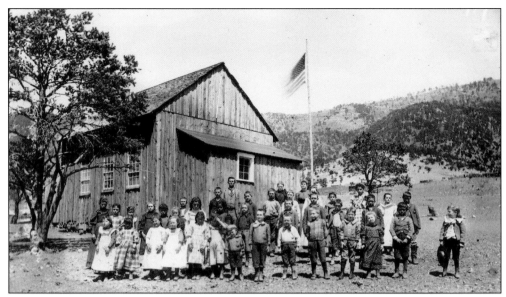

The population of Kelly included families as well as unmarried miners. There were soon enough children to warrant Kelly having its own school. The school was photographed by Joseph E. Smith around 1890. Smith's son, Marvel, is the boy standing apart on the right. (Courtesy of Suzanne Smith, Joseph E. Smith Collection.)

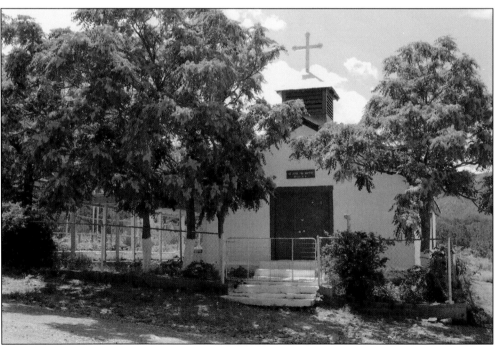

The Church of St. John the Baptist is the only building still standing in the mining town of Kelly. The church, located five miles south of Magdalena, is maintained by the people of Magdalena. It still hosts an annual mass and fiesta, allowing the church to remain on the rolls as an active mission church of the Archdiocese of New Mexico. (Author's collection.)

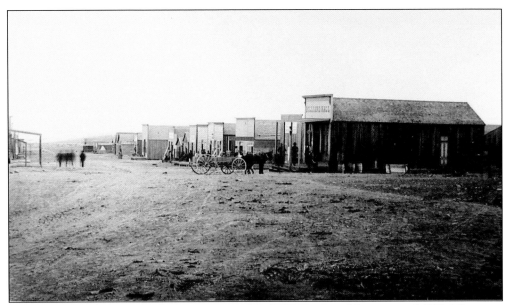

The Billing Smelter created the community of Park City, pictured here around 1890. The town boasted adobe and tent residences, a church, a boardinghouse, an elementary school, furniture store, bowling alley, and its own post office. Park City's population was almost 400 people in 1890. (Courtesy of Suzanne Smith, Joseph E. Smith Collection.)

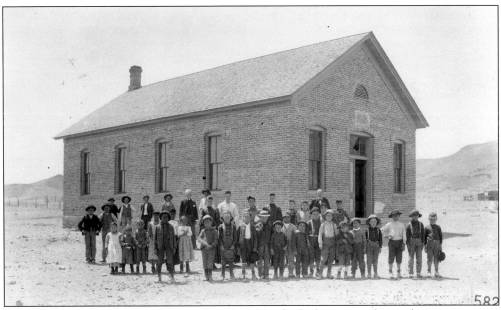

By 1900, when this photograph was taken, Park City had a large enough population to warrant its own elementary school. The school was constructed of bricks manufactured in Socorro at the old Graphic smelter, which had been converted to produce fire bricks. (Courtesy of Suzanne Smith, Joseph E. Smith Collection.)

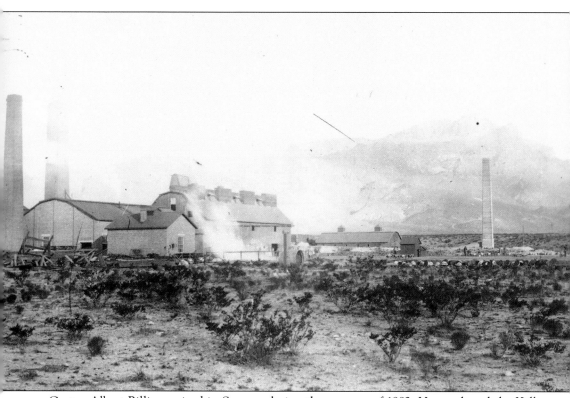

Gustav Albert Billing arrived in Socorro during the summer of 1882. He purchased the Kelly Mines for $40,000 from Patrick Dorsey and his associates. Billing then built a smelter at a site two miles west of Socorro's plaza called Park City. Billing's smelter was the first large-scale industrial operation in New Mexico, and by January 1884, more than 2,000 tons of bullion had been produced. The purpose of a smelter is to reduce raw ore into a more compact, easily transported form. The ore processed in Billing's smelter was made up of 35 percent lead and 10 ounces of silver per ton. Each ton of ore yielded seven bars of bullion, or pigs. The pigs were shipped by rail to St. Louis for further refining. (Courtesy of Suzanne Smith, Joseph E. Smith Collection.)

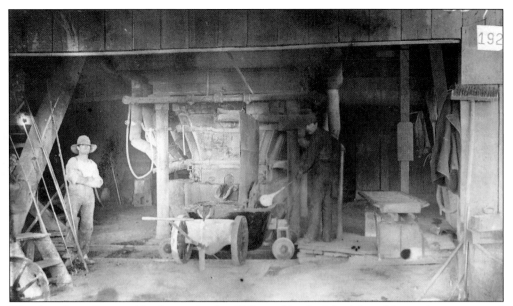

The abundant silver and lead ore mined at Kelly and in the Magdalena Mountains encouraged Gustav Billing to establish a smelter at Park City, just southwest of Socorro. This transformed Socorro into the smelting center of the Southwest. (Courtesy of Suzanne Smith, Joseph E. Smith Collection.)

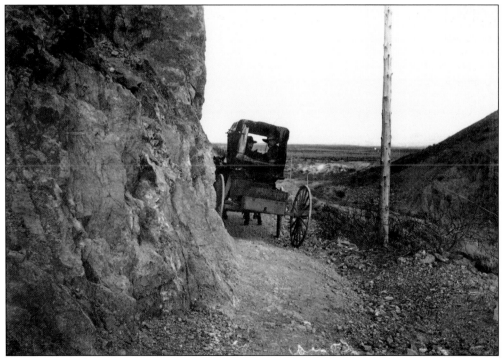

The *Socorro Chieftain* reported on August 6, 1883: "The road to Magdalena is in a miserable condition. The heavy ore teams have cut it into pieces and especially in Socorro Pass it is filled with chuck holes. Every day the difficulty of travel increases, and there will be an absolute necessity of doing something very soon." (Courtesy of Suzanne Smith, Joseph E. Smith Collection.)

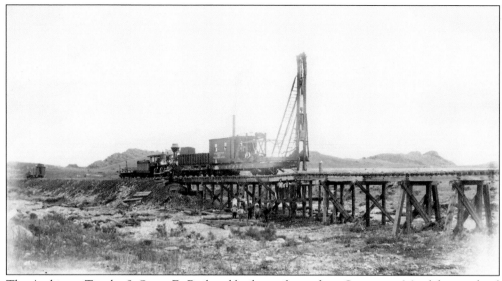

The Atchison, Topeka & Santa Fe Railroad built a rail spur from Socorro to Magdalena to haul ore from the mines at Kelly to the smelter at Park City, located southwest of the Socorro Plaza. Santa Fe pile driver No. 7 is shown here in 1886, just west of Socorro, constructing a bridge to span an arroyo. (Courtesy of Suzanne Smith, Joseph E. Smith Collection.)

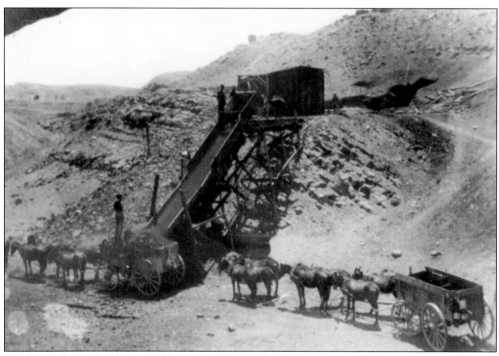

Carthage, about 10 miles east of San Antonio, was the site of the Government Mine, the first coal mine in New Mexico. In the 1860s, US soldiers mined coal at Carthage to fire the blacksmith forges at Forts Selden, Bayard, and Stanton. Pictured here is the coal tipple and mule-team wagons that were used to haul the coal to San Antonio, prior to the building of the railroad spur. (Courtesy of Socorro County Historical Society.)

There was no coal-mining activity in Carthage for 10 years, after the mines were closed in 1893. Shortly after the turn of the century, the New Mexico Midland Railway rebuilt the tracks on the original Santa Fe grade between San Antonio and Carthage. Several Socorro and San Antonio citizens reopened the coal mines in Carthage. By 1907, the population of Carthage had grown to 1,000 residents. (Courtesy of Socorro County Historical Society.)

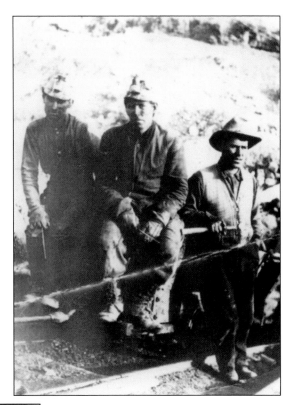

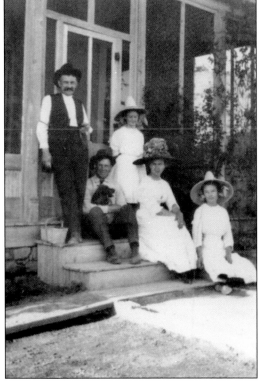

Robert McIntyre, standing at left, poses with his family at their home in Carthage. In 1881, the Atchison, Topeka & Santa Fe Railroad (AT&SF) stimulated coal-mining activity by building a bridge across the Rio Grande and constructing a spur line from Carthage to the rail yard in Socorro. The coal was used to fire AT&SF locomotives and in the ore smelters near Socorro. (Courtesy of Socorro County Historical Society.)

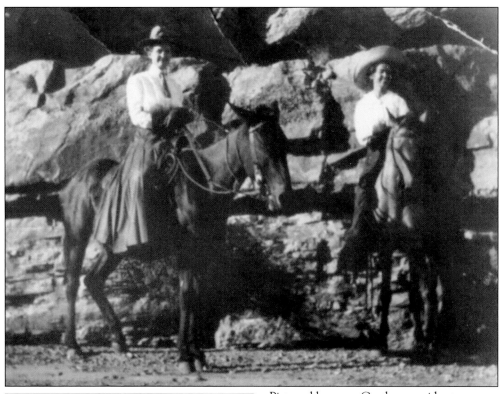

Pictured here are Carthage residents Mrs. John Hart (left), wife of the mine superintendent, and Elizabeth Binks. This photograph was probably taken sometime before 1893. Questions about land titles connected to an old Spanish land grant caused the Atchison, Topeka & Santa Fe railroad to abandon coal mining at Carthage. Most of the houses and mine equipment were moved to Madrid, New Mexico. (Courtesy of Socorro County Historical Society.)

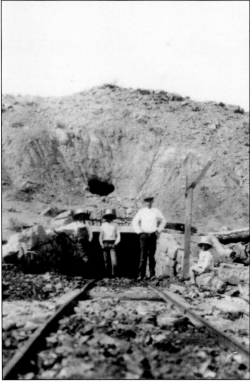

Eugene (left), Johnny (center), and Robert Duffy pose outside the entrance to the reopened coal mine in Carthage in 1927. At this time, Carthage was in the midst of its second era of coal-mining activity due to the investment of several Socorro and San Antonio businessmen. (Courtesy of Socorro County Historical Society.)

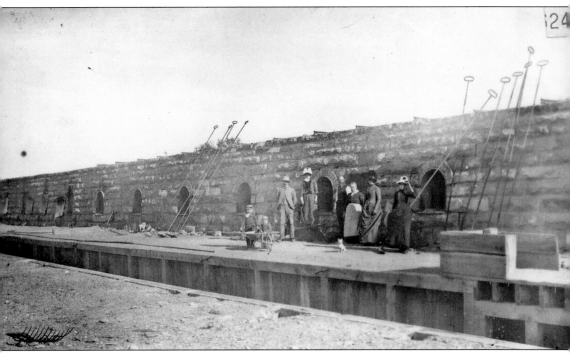

Pictured here are the coke ovens of the San Pedro Coal & Coke Company at San Antonio. Coke is a high-carbon fuel produced from coal. It is made by baking coal in an airless furnace at temperatures as high as 2,000 degrees Fahrenheit. Coke is used as a fuel and as a reducing agent in ore-smelting processes. (Courtesy of Suzanne Smith, Joseph E. Smith Collection.)

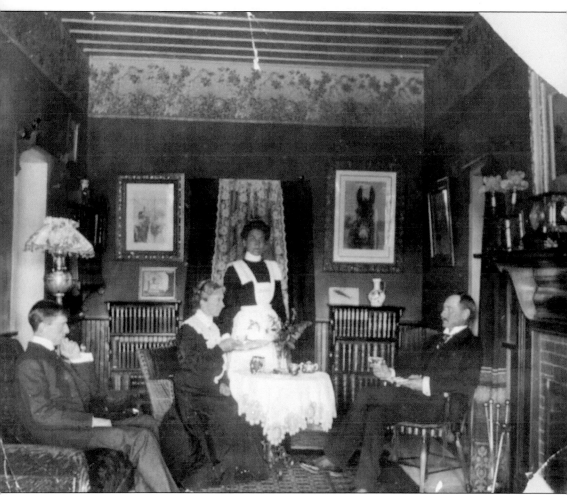

Charles B. Allaire (right), his wife, Lucy (seated), and son Pierre are pictured in their house in San Antonio, New Mexico. Charles Allaire arrived in San Antonio in 1900 and purchased a mercantile store from the Price brothers of Socorro. Lucy Allaire was famous for serving afternoon tea daily at 4:00. Note the curious portrait on the wall to the right. (Courtesy of Socorro County Historical Society.)

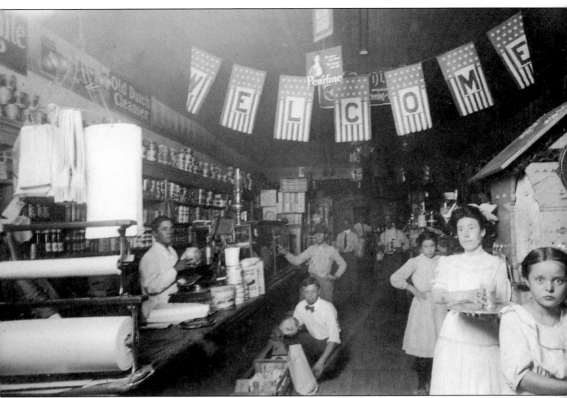

The interior of the Allaire, McIntyre Mercantile Company in San Antonio is seen here around 1910. The store sold everything from baby bottles to caskets. Charles B. Allaire also built several warehouses near the store to hold wool and other agricultural products awaiting shipment by rail to other markets. (Courtesy of Socorro County Historical Society.)

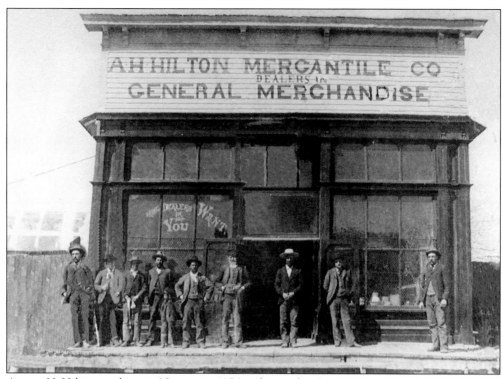

August H. Hilton was born in Norway in 1856 and moved to San Antonio, New Mexico, in 1881. He started the Hilton Mercantile Company in 1888, where he employed his son Conrad and his nephew Holm Bursum Sr. August Hilton served as the postmaster at San Antonio for more than 17 years. (Courtesy of Socorro County Historical Society.)

Pictured here is hotel magnate Conrad Hilton, son of August Hilton. Conrad got his start in the hotel business by working in his father's hotel in San Antonio. He was elected to the first New Mexico state legislature in 1912, before he started a career building hotels in cities around the world. In 1942, he married Zsa Zsa Gabor in Santa Fe, New Mexico. (Courtesy of Socorro County Historical Society.)

Five

THE NEW MEXICO SCHOOL OF MINES

In February 1889, the New Mexico Territorial Legislature passed a general education act creating the University of New Mexico at Albuquerque, the New Mexico College of Agriculture and Mechanical Arts at Las Cruces, and the New Mexico School of Mines at Socorro.

Section 28 of that act pertained to the School of Mines. That section stated: "The object of the School of Mines created, established, and located by this act, is to furnish for the education of such persons as may desire to receive instruction in chemistry, metallurgy, mineralogy, geology, mining, milling, engineering, mathematics, drawing, the fundamental laws of the United States and the rights and duties of citizenship, and such other courses of study, not including agriculture, as may be prescribed by the Board of Trustees."

On September 5, 1893, seven students composed the first class at the School of Mines. The school's enrollment grew slowly but steadily. During World War I, enrollment dropped to the lowest point since the school was founded, but by the 1920s, almost 100 students were attending. The bond between the School of Mines and the community of Socorro also became stronger during this period. In 1927, the businessmen of Socorro gave a smoker for the freshman class at the Val Verde Hotel. Socorro residents were in turn invited to school social affairs.

The Great Depression, as well as the attendant lack of employment prospects, resulted in a dramatic increase in student enrollment at the School of Mines. In the 1937–1938 school year, 176 students were enrolled, the highest in the school's history. That figure was not eclipsed until the GI Bill fueled a student surge after World War II. By the fall of 1947, approximately 213 students were enrolled. In 1964, enrollment had reached 419 students, and 1,381 students were attending the school in 1982.

In 1951, at the request of the administration, and with the approval of the board of regents, the school's name was changed to the New Mexico Institute of Mining and Technology.

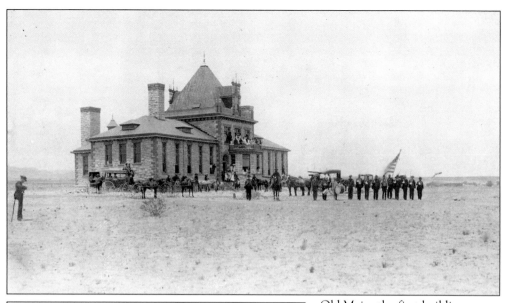

FIRST ANNUAL ANNOUNCEMENT

AUGUST, 1893,

OF THE

NEW MEXICO

SCHOOL OF MINES

SOCORRO, NEW MEXICO.

FIRST TERM OPENS SEPT. 5, 1893

Old Main, the first building erected on the New Mexico School of Mines campus, is seen during its dedication. The building was completed in 1893. The stone for the building was gray trachyte from Blue Canyon in the Socorro Mountains. The trim was red Arizona sandstone. The building housed analytical laboratories, lecture rooms, a museum, and a library. The building's construction cost $43,940. Old Main was destroyed by fire in 1928. (Courtesy of Socorro County Historical Society, Joseph E. Smith negative no. 485.)

The first term of instruction at the New Mexico School of Mines opened on September 5, 1893. In 1889, several Socorro landowners, including Juan Jose Baca, Esteban Baca, Severo A. Baca, Edwin Hubbard, Jacob Naumer, Robert Collins, and Antonio Abeyta y Montoya deeded almost 23 acres to the school for the sum of $1. (Courtesy of Suzanne Smith, Joseph E. Smith Collection.)

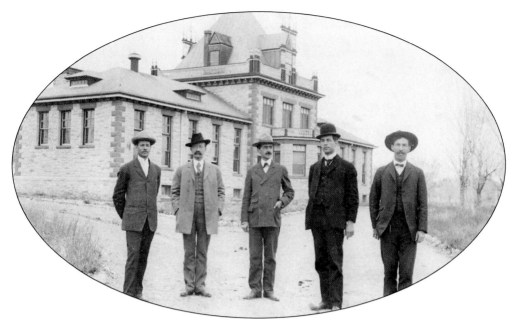

Pictured here are members of the Board of Regents of the School of Mines. Seen here, from left to right, are Thomas Harwood, president of the board; Ethan W. Eaton, secretary and treasurer; W. George Waring from Silver City; and J.J. Baca and H.H. McChesney, both from Socorro. William T. Thornton, governor of the Territory of New Mexico, and Amado Chaves, superintendent of public instruction, were ex officio members of the board. (Courtesy of Socorro County Historical Society, Joseph E. Smith negative no. 482.)

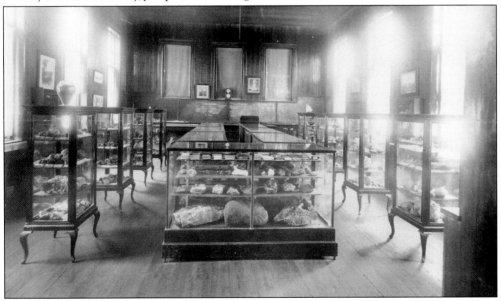

The geological museum at the School of Mines was located in the north wing of Old Main. The collection of more than 2,000 mineral and ore specimens was displayed in 22 glass cases. An additional 2,500 specimens were stored in wall cabinets. Many of the finest specimens were collected and donated to the museum by Cony T. Brown. (Courtesy of Socorro County Historical Society.)

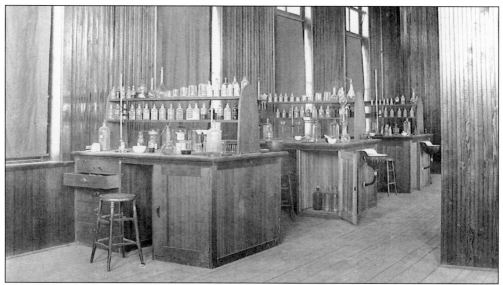

The first chemistry laboratory at the School of Mines, pictured here around 1900, was located in Old Main. (Courtesy of Suzanne Smith, Joseph E. Smith Collection.)

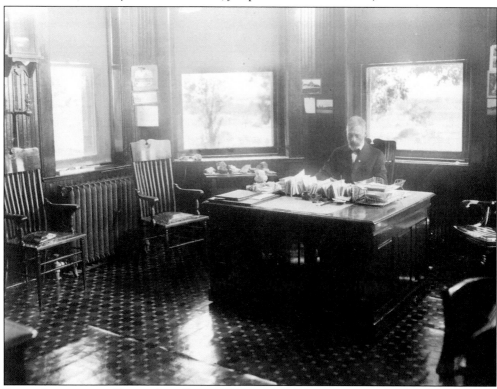

Fayette Jones, pictured here in his office in Old Main, served two terms as president of the college. He was president from 1898 to 1902 and from 1913 to 1917. Jones was constantly promoting mining and New Mexico's mineral resources throughout the state and the nation. He was chairman of the committee planning the New Mexico mining display at the 1904 International Exposition in St. Louis. (Courtesy of Socorro County Historical Society.)

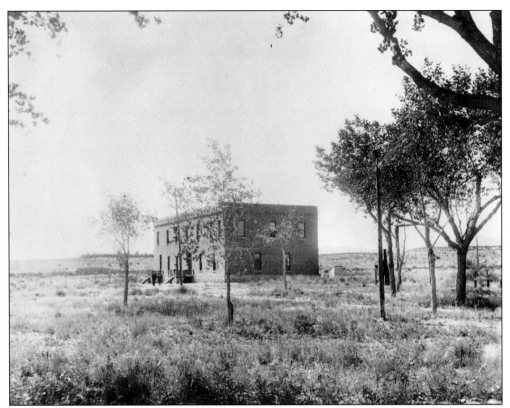

Driscoll Hall was the first dormitory on the School of Mines campus. The building, which was completed in 1908, served the campus for 73 years. Driscoll was remodeled as a women's dorm in the 1960s. It was condemned and torn down in 1981, when new Dricsoll Hall was built. (Courtesy of Socorro County Historical Society.)

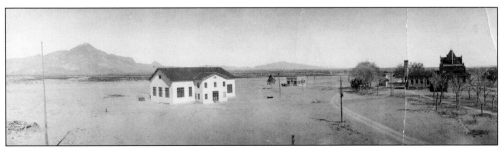

This photograph was taken from the roof of Driscoll Hall around 1900. The gymnasium is the large white building; the smaller building in the center of the photograph is the power plant for the campus. Old Main is the building on the right. (Courtesy of Socorro County Historical Society.)

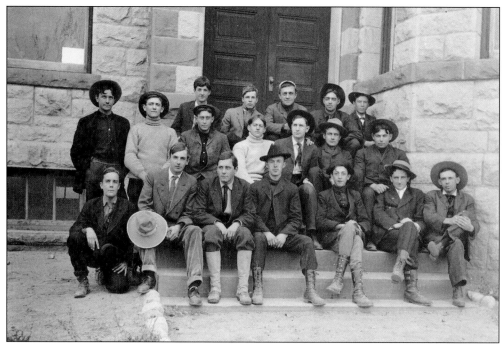

A School of Mines class poses around 1920. Marvel Smith, son of Joseph E. Smith, is second from left in the third row. Joe Hilton, son of Joseph Hilton, who owned the Hilton Drug Store in Socorro, is fourth from left in the second row. (Courtesy of Suzanne Smith, Joseph E. Smith Collection.)

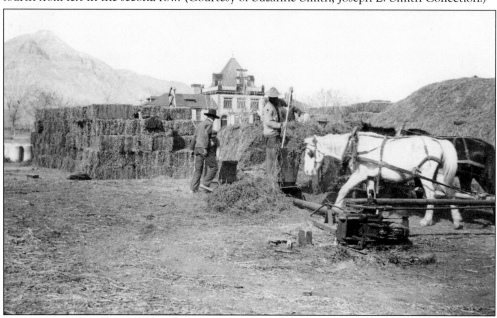

Although the New Mexico School of Mines was located in Socorro, agriculture was still an important element of the town's economy. In this c. 1910 photograph, taken in front of Old Main on Cony T. Brown's farm, alfalfa is being baled by a stationary baling machine. The cut hay was transported from the field to the baler, and horses turned a driveshaft to provide power. (Courtesy of Socorro County Historical Society.)

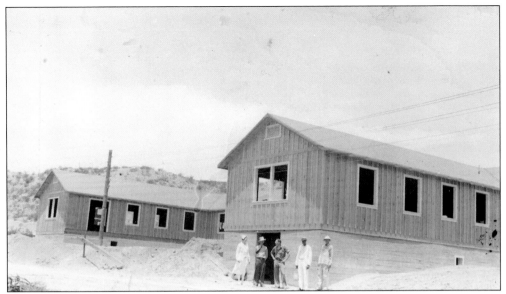

These barracks buildings were constructed by Civilian Conservation Corps (CCC) workers in the 1930s at the CCC camp a few miles north of Socorro. When the CCC was disbanded at the start of World War II, the buildings were moved to the campus of the School of Mines. They can be seen in the lower right corner of the aerial photograph of the campus (below). (Courtesy of Socorro County Historical Society.)

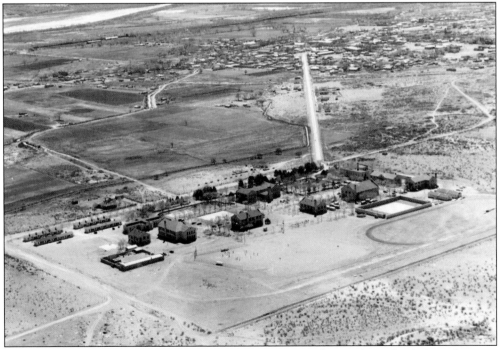

This aerial photograph of the School of Mines campus was taken in the early 1940s to showcase the new campus buildings constructed by the Works Progress Administration (WPA). The road heading southeast from the campus is School of Mines Road. (Courtesy of Socorro County Historical Society.)

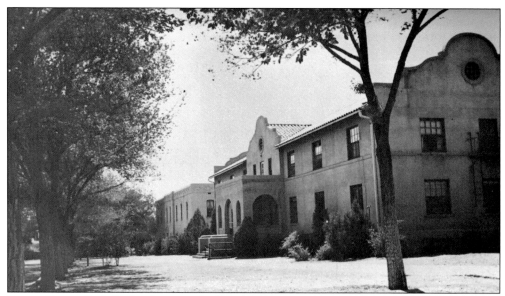

Pictured here is Fitch Hall, a dormitory built in the 1930s, one of many campus buildings constructed by the Works Progress Administration (WPA). Fitch Hall was still in use in 1989, the 100th anniversary of the school. Driscoll Hall is in the background. (Author's collection.)

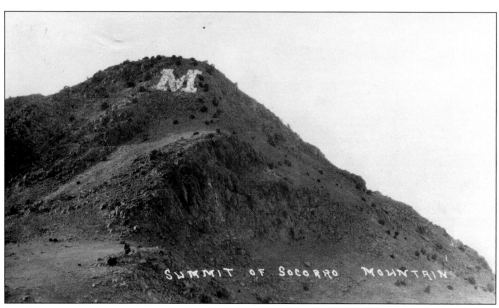

The "M" atop Socorro Peak was first laid out between 1911 and 1912 by Frank J. Maloit. Lime and water to paint the letter were hauled up the mountain by burros. Melted snow was used to add to the water hauled by the pack animals. Freshman students at the School of Mines had the task of repainting the "M" annually in the spring. (Courtesy of Socorro County Historical Society.)

Six

FIRES, FLOOD, AND LAW AND ORDER

The Socorro Hose Company No. 1 was organized around 1891 as an all-volunteer organization. Since fire was one of the major threats to public safety, firefighters were very highly regarded members of the community.

Several fires on or near the plaza have caused major destruction. Several businesses were destroyed in the 1886 fire on the south side of the plaza. The Loma Theater and Keith's Ocean to Ocean Garage burned down in 1957, and in 1958, Grimes Variety Store burned down (that area is now occupied by Gambles Big Value Hardware store and Gene's Flower Shop). Louis Grandjean, a volunteer with the Socorro Fire Department in the 1940s and 1950s, was also campus fire chief at the School of Mines.

Flooding was a fact of life in Socorro and in nearby communities situated along the Rio Grande. A major flood occurred in the area at least every 10 years between 1880 and 1940. The flood of 1929 caused extensive damage in Socorro and completely destroyed the town of San Marcial.

After the 1929 flood, the Mid-Rio Grande Conservancy District established a series of drainage ditches and diversion channels to control flooding in the area. In the 1960s, the US Army Corps of Engineers built a flood control channel to divert runoff from the Socorro Mountains to the Rio Grande near Escondido. There has not been major flooding in the area since then.

The earliest law-and-order issues in Socorro centered on control of raiding Apache and Comanche Indians. The Indian raids ceased after the capture of Geronimo in 1886, but other forms of lawlessness had to be dealt with. Murders, robberies, and cattle rustling were all too common, and official law-enforcement agencies were generally incapable of dealing with these problems. As a result, a citizen's Committee of Justice was formed, under the leadership of Col. Ethan W. Eaton. This group enforced law and order in Socorro from 1881 to 1885.

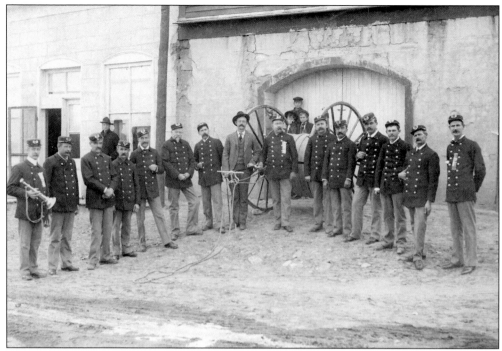

This is the Socorro Hose Company No. 1, photographed in 1903. Pictured here are, from left to right, A.F. Katzenstein, J. Bowman, August Winkler, William Hammel, R.T. Collins, Capt. Cooney, Amos Green, Ed Keeler, Abraham Coon, E. Meyer, S. Abeyta, J. Campredon, Leo Gransy, Joe Eppele, and Pat Savage. The Katzenstein children are in the background. (Courtesy of Socorro County Historical Society.)

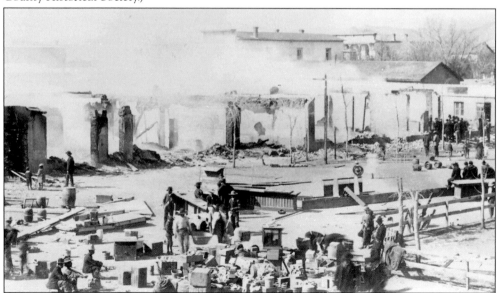

On April 6, 1886, a fire that started in the Brunswick Saloon on the south side of the plaza burned six mercantile businesses and two saloons. This photograph was taken from in front of the building that housed the Hilton Drug Store. One man, G.E. Wards, was killed in the fire. (Courtesy of Socorro County Historical Society, Joseph E. Smith negative no. 334)

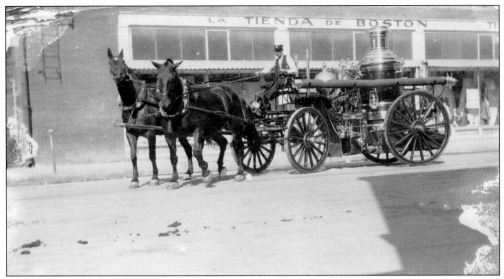

Popular from about 1860 to 1920, steam-powered pumper fire engines were in use throughout the United States. The vertical steam boiler was used to produce pressure to provide a stream of water to fight the flames. After about 1910, horses were retired, and the pumpers were pulled by gasoline vehicles. (Courtesy of Socorro County Historical Society.)

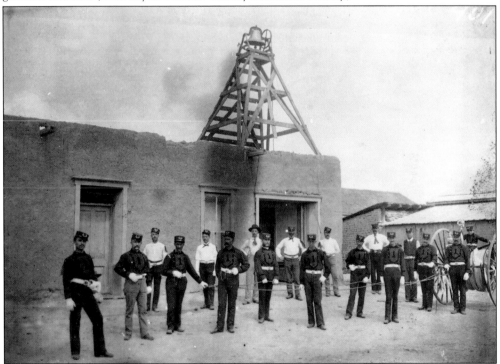

Members of Hose Company No. 1 of the Socorro Fire Department pose around 1907. The bell at the top of the wooden tower served as a fire alarm. The tower also was used to hang fire hoses to drain and dry out. Fire was a constant danger in all frontier towns, and volunteer firemen were often among the most prominent members of the community. (Courtesy of Suzanne Smith, Joseph E. Smith Collection.)

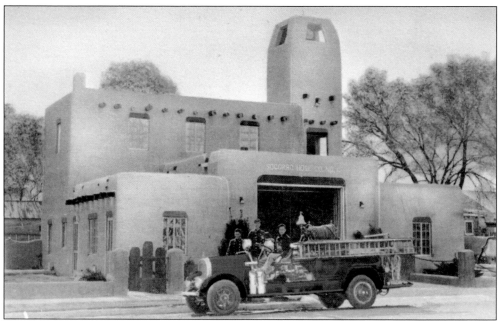

The second building for the Socorro Hose Company No. 1, pictured here, was built in the late 1930s as a New Deal WPA project. This building was erected on the site of the first fire station, which was built in 1907. The American La France fire truck in front of the station is still owned by a local resident. (Courtesy of the David Ortiz Collection.)

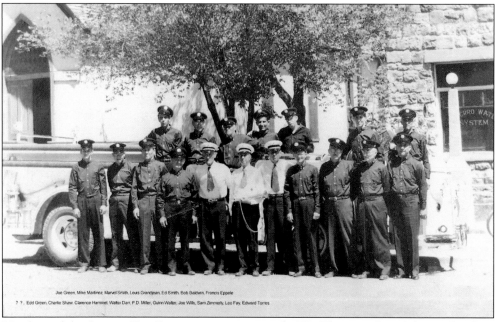

Members of the Socorro Fire Department pose around 1950. They are, from left to right, (first row) unidentified, Edd Green, Charlie Shaw, Clarence Hammel, Walter Darr, P.D. Miller, Guinn Walter, Joe Willis, Sam Zimmerle, Leo Fay, and Edward Torres; (second row) Joe Green, Mike Martinez, Marvel Smith, Louis Grandjean, Ed Smith, Bob Baldwin and Francis Eppele. (Courtesy of Socorro County Historical Society.)

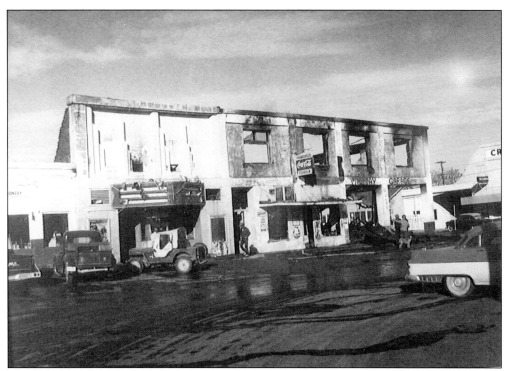

The Gem Theater, renamed the Loma, was destroyed by fire along with Keith's Garage and other buildings in 1957. A drive-in theater south of Socorro supplied movie entertainment until the Loma was reestablished in its present location, next to First State Bank on Manzanares Avenue. (Courtesy of Socorro County Historical Society.)

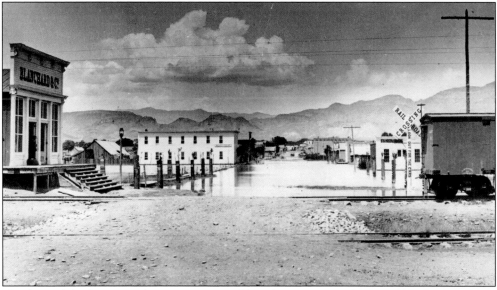

Flooding of the Rio Grande was a major problem for Socorro and surrounding communities. This photograph was taken looking west on Manzanares Avenue from the train depot in 1896. Significant floods occurred in the Socorro area nearly every decade, in 1881, 1884, 1886, 1889, 1890, 1896, 1911, 1920, 1929, 1937, and 1941. (Courtesy of Socorro County Historical Society.)

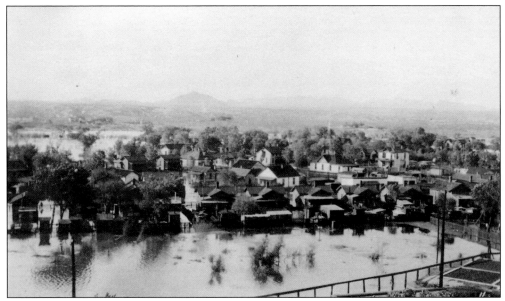

One of the worst floods to hit the area occurred in August, and again in September 1929. The two floods, coming less than a month apart, caused the ultimate abandonment of the town of San Marcial. This photograph was taken from the top of the water tank for the AT&SF in San Marcial. (Courtesy of Socorro County Historical Society.)

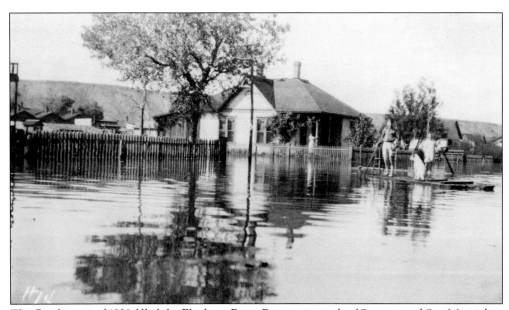

The floodwaters of 1929 filled the Elephant Butte Reservoir, south of Socorro and San Marcial, at Truth or Consequences, New Mexico. Because Elephant Butte was full, floodwaters in San Marcial took months to recede. These boys and their dog are using the only means of transportation available at the time. (Courtesy of Socorro County Historical Society.)

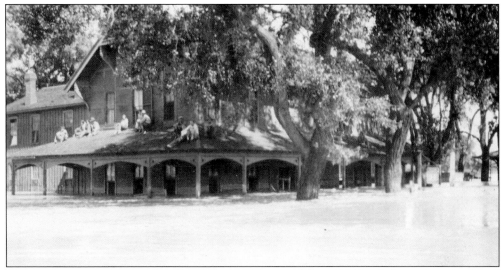

The Fred Harvey House in San Marcial was a victim of the 1929 flood. Several residents and staff, including Harvey Girls, of the railroad hotel can be seen taking refuge on the roof of the building. Monetary damage due to the flood was estimated at more than $1 million (almost $14 million today). (Courtesy of Socorro County Historical Society.)

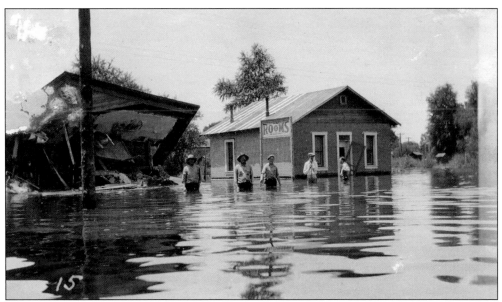

The depth of the waters from the 1929 flood is evident here. Nearly 2,500 people lived in San Marcial at the time of the flood. The Atchison, Topeka & Santa Fe Railroad began immediately relocating nearly 500 employees and their families to railroad facilities in Albuquerque, Belen, and El Paso, abandoning operations in San Marcial. (Courtesy of Socorro County Historical Society.)

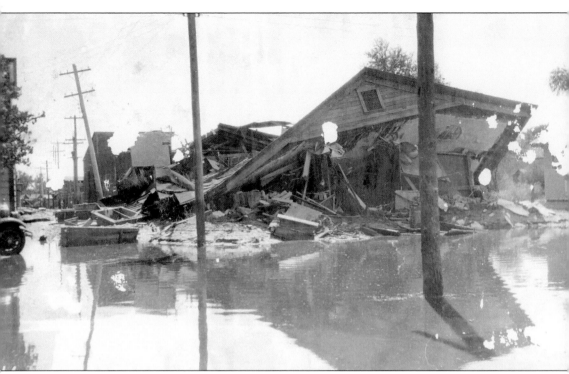

Most of the buildings in San Marcial were constructed of adobe bricks. Floodwaters seeped into the walls and wicked upward, and the weight of the roof of buildings caused them to collapse. This photograph shows what was left of the opera house in San Marcial. (Courtesy of Socorro County Historical Society.)

This photograph was taken inside the AT&SF roundhouse at San Marcial prior to the flood of 1929. A locomotive, pulled into the roundhouse for service, can be seen in the background. Early steam locomotives often did not have the capability to travel in reverse, so roundhouses incorporated a turntable to allow the engine to change direction. (Courtesy of Suzanne Smith, Joseph E. Smith Collection.)

This is the interior of the Atchison, Topeka & Santa Fe Railroad shop after floodwaters receded in October 1929. Because the water took so long to drain back to the river, huge deposits of silt accumulated. (Courtesy of Socorro County Historical Society.)

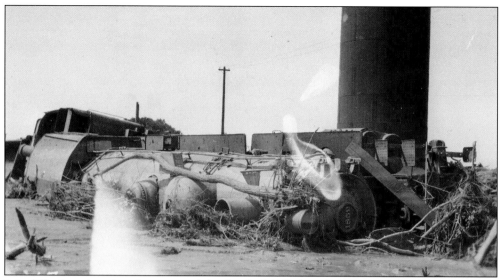

It is difficult to imagine the power of the flood of 1929, but this photograph of an overturned freight engine (Santa Fe No. 1859) in the San Marcial rail yard gives some idea. (Courtesy of Socorro County Historical Society.)

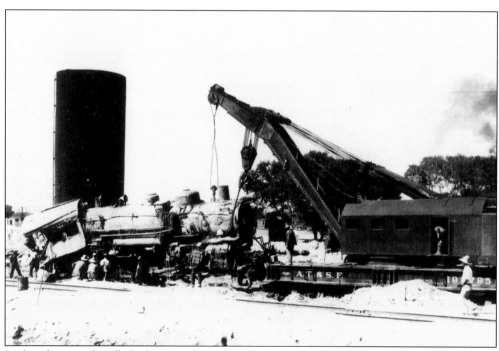

In this photograph, a flatbed crane is being used to hoist engine No. 1859 off the tracks. After the flood, the AT&SF abandoned all operations in San Marcial and relocated them to Albuquerque, Belen, and El Paso, Texas. (Courtesy of Socorro County Historical Society.)

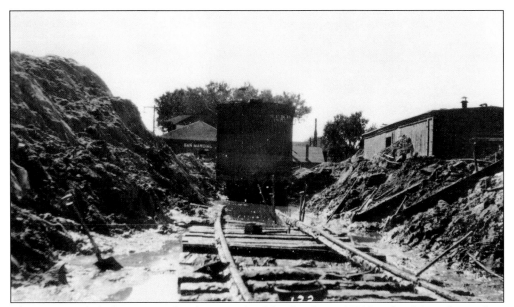

The amount of silt that accumulated as a result of the flooding of 1929 in San Marcial is evident here. The San Marcial depot can be seen on the right. Even though the town was abandoned after the flood, the railroad tracks needed to be cleared and repaired in order to resume rail service from Albuquerque to El Paso. (Courtesy of Socorro County Historical Society.)

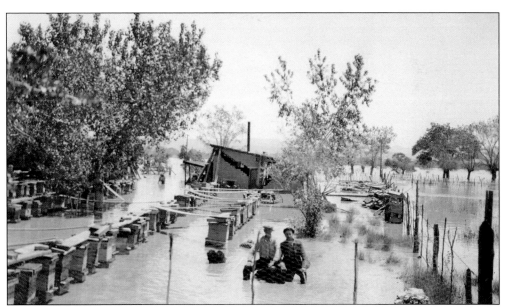

The town of Socorro was also extensively damaged several times by the Rio Grande floods. Pictured here is Sickles Bee Ranch, owned by George Sickles, during the flood of 1921. (Courtesy of Socorro County Historical Society.)

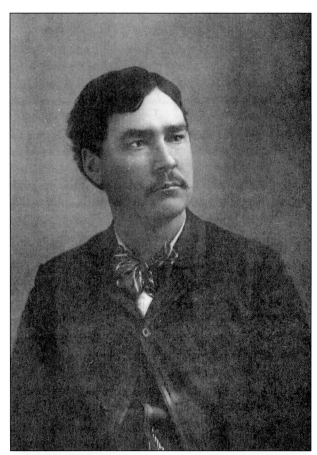

Elfego Baca was born in Socorro in 1865. On November 30, 1884, at Frisco Plaza, near Reserve in western Socorro County, he was involved in a gunfight with a group of at least 20 Texas cowboys. Baca sought refuge in a cabin, and the cowboys fired many rounds into the building, but Baca was unharmed. Elfego Baca later became a lawyer and practiced for many years in Albuquerque, where he died in 1945. (Author's collection.)

Ethan W. Eaton (right) poses with his brother Isaac at the Amador Studio in Las Cruces, New Mexico, around 1890. Ethan Eaton was born in Montgomery County, New York, in 1827. He was captain of Company F, 2nd New Mexico Volunteers, at Fort Craig during the Civil War Battle of Valverde in 1862. He was appointed deputy sheriff in 1881 and was mayor of Socorro in 1884. (Courtesy of Socorro County Historical Society.)

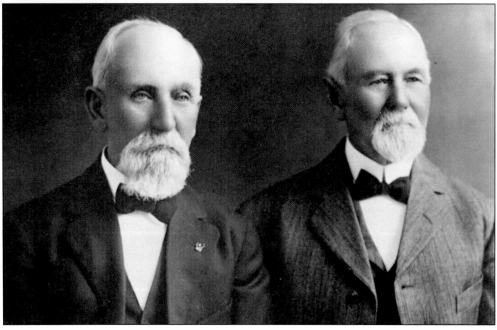

This is the home of Ethan W. Eaton. The house was built in the 1890s. Colonel Eaton was the leader of a group of men unofficially dedicated to keeping the peace in Socorro. In the three years that the vigilantes controlled Socorro, six men—Tom Gordon, Onofre Baca, Juan Aliri, Joel Fowler, and two men known only as "Frenchy" and "The Kid"— were hanged. (Courtesy of Socorro County Historical Society.)

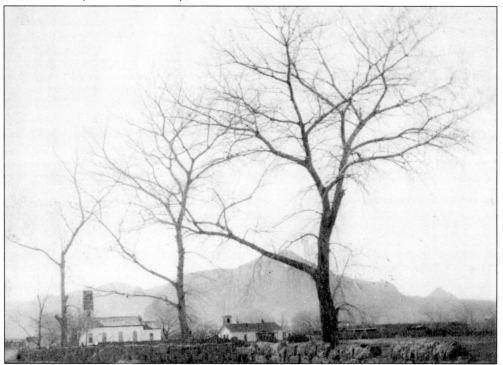

"Judge Lynch" held court and carried out sentencing in Socorro's Death Alley. Pictured here in a c. 1890 Joseph E. Smith photograph, Death Alley was located on Garfield Street in Socorro. (Courtesy of Suzanne Smith, Joseph E. Smith Collection.)

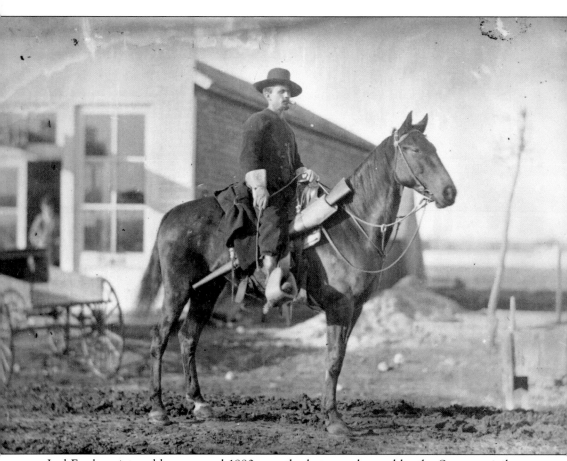

Joel Fowler, pictured here around 1880, was the last man hanged by the Socorro vigilantes. Fowler, reported to be an educated man and peaceful unless he had been drinking, came to town one day in 1883, got drunk, and killed a man. He was tried for murder in November 1883 and found guilty. Townspeople feared he might escape punishment, so the vigilantes broke down the jailhouse door, dragged Fowler to Death Alley, and hanged him. The body was placed on view the following day and was seen by more than 3,000 people. (Courtesy of Suzanne Smith, Joseph E. Smith Collection.)

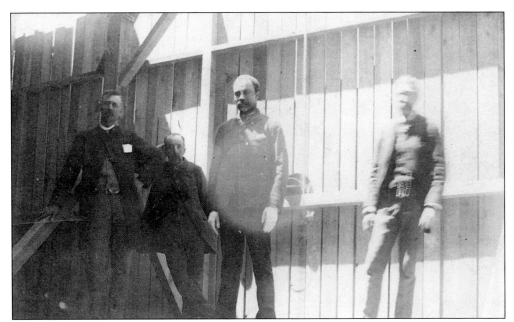

The hanging of Henry Anderson on May 6, 1887, was a legally authorized execution, as opposed to the lynchings carried out by the Socorro Committee of Public Safety. Shown here are, from left to right, the Reverend S.A. Russel, Sheriff George Cook, Henry Anderson, and Al Robinson. Anderson's was one of three executions carried out in Socorro during the territorial period (1849–1908). (Courtesy of Suzanne Smith, Joseph E. Smith Collection.)

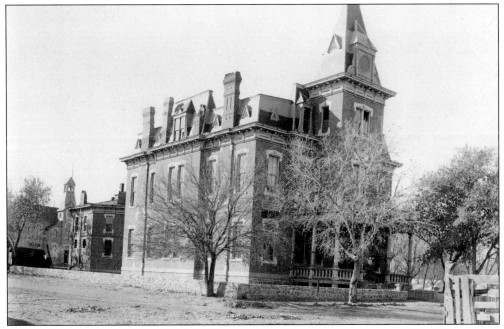

This is the second courthouse built in Socorro. The first one was constructed in 1851 and was used until 1884, when the second courthouse (pictured) was erected. It was demolished in 1939 by New Deal Works Progress Administration (WPA) workers. (Courtesy of Suzanne Smith, Joseph E. Smith Collection.)

The present Socorro County Courthouse (pictured) was built in 1939 as a New Deal WPA project during the Depression. The Pueblo Revival building is still in use today. (Author's collection.)

Seven

RECREATION

Residents of Socorro and the surrounding communities had many outlets for diversion and recreation. The nearby Socorro, Magdalena, and San Mateo Mountains provided many locations for hunting, camping, hiking, and horseback riding. People swam in the waters of Socorro Springs and the Rio Grande.

Baseball was one of the most popular organized activities, and teams from Socorro regularly competed with teams from Albuquerque, Santa Fe, Las Vegas, Silver City, and Raton. Some of the most heated competition was between local baseball teams from Socorro, Magdalena, Carthage, Kelly, and Park City.

Socorro and San Marcial both had opera houses where theatrical performances were held, and personalities like Capt. Jack Crawford gave Chautauqua presentations. Musical groups, both formally organized and impromptu, were also popular.

In 1887, as part of the San Miguel festival, a bullring was constructed in Park City, and more than 15,000 people attended a series of bullfights staged by bullfighters from Mexico.

Holidays, especially the Fourth of July, were popular occasions for entertainment. Businesses closed, and entertainment included fireworks, horse- and footraces, and picnics. Horse racing was especially popular in Magdalena, and an active horse-breeding program flourished.

Local saloons provided a popular place for residents to gather for a drink, a game of pool or poker, or conversation with friends. It was not unusual for saloons to outnumber churches in Socorro, but both institutions served similar civic and social functions.

The automobile replaced the horse and buggy as the major means of transportation in Socorro County, and it served recreational as well as utilitarian purposes. Cars made it easier to visit nearby families, and "just taking a drive" became a popular pastime. The Socorro business community also benefited from the automobile, as service stations replaced livery stables, and hotels and restaurants catered to a new influx of travelers who came to the city by car.

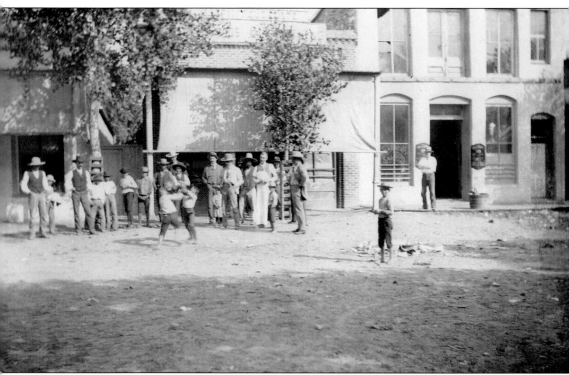

Spectator sports took many forms in early Socorro. There were regularly scheduled horse races, organized semiprofessional baseball games, and impromptu outings and picnics. Pictured here is a more informal form of spectator sport, a boxing match in the street between two boys. These young combatants, photographed in the 1880s by Joseph E. Smith, had the benefit of boxing gloves. (Courtesy of Socorro County Historical Society, Joseph E. Smith negative no. 271.)

In addition to being a practical means of transportation, horseback riding was a popular recreational activity in Socorro. Julia Sickles, mounted sidesaddle, poses in front of Kittrell Park around 1890. Julia Sickles and her husband, George, operated a hotel in Socorro in the early 1900s. It was destroyed by fire in 1921. (Courtesy of Socorro County Historical Society.)

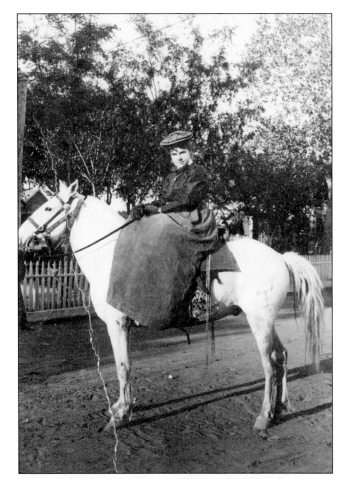

Game was plentiful in the mountains near Socorro, and hunting was a popular pursuit, both to provide food for the table, as well as for sport. George L. Sickles, his wife Julia Sickles, and their son George are shown here on a hunting trip in the early 1920s. (Courtesy Socorro County Historical Society.)

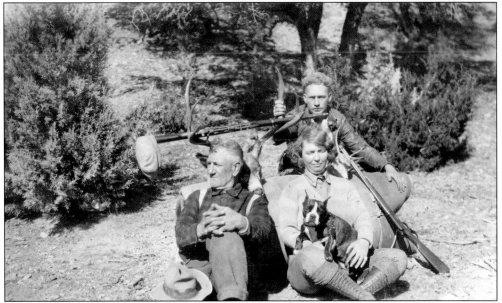

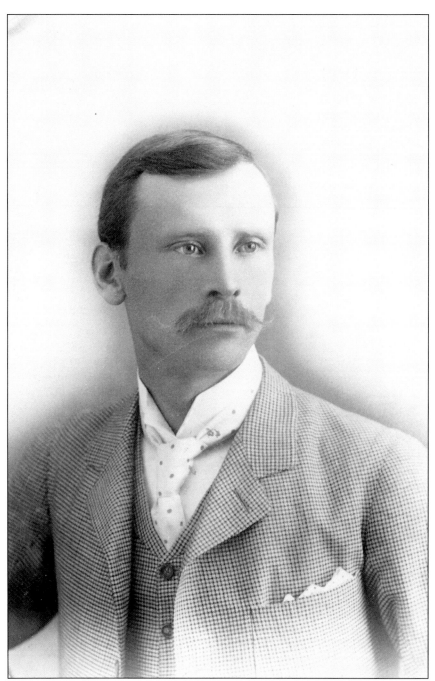

Montague Farquhar Sheffields Stevens (1859–1953) was born in Madras, India, and studied at Cambridge University in England. In 1879, he participated in a big-game hunt in Wyoming and visited New Mexico. He returned to the Socorro area in 1882 and used an inheritance to purchase several ranches, raising more than 20,000 head of cattle and 16,000 sheep. He also owned several sawmills. He was perhaps best known as a big-game hunter, having killed, by his own count, 18 grizzly bears. He accomplished this feat despite having lost an arm in a goose-hunting accident. (Courtesy of Suzanne Smith, Joseph E. Smith Collection.)

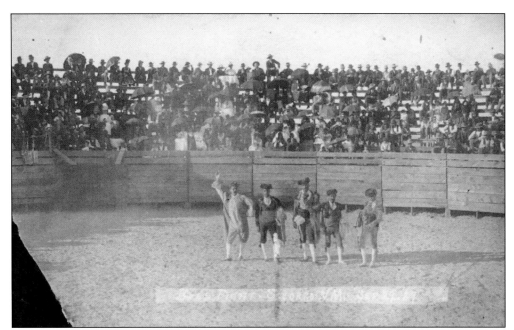

This photograph of the bull ring in Park City was taken by Joseph E. Smith. From September 29 to October 3, 1887, the Compania de Torreros of Chihuahua, Mexico, staged a series of bullfights. The bull ring was constructed specifically for these events. (Courtesy of Suzanne Smith, Joseph E. Smith Collection.)

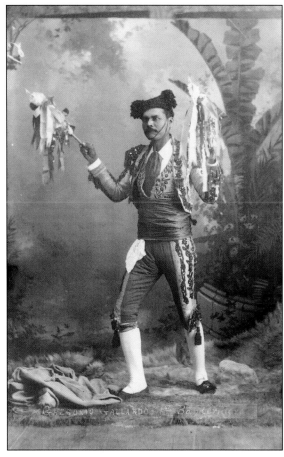

In 1887, a group of Mexican bullfighters from Chihuahua staged bullfights in a ring constructed in Park City. Pictured in this portrait by Joseph E. Smith is Gregorio Gallardo, first *banderillero*. A *banderilla* is a decorated barbed dart that the *banderillero* thrusts into the neck or shoulder of a bull while passing as close as possible to the bull's horns. (Courtesy of Suzanne Smith, Joseph E. Smith Collection.)

Music was one popular form of entertainment in Socorro, performed by professional musicians and amateurs alike. These women are gathered at the home of Elizabeth Wickham Mills, standing in the back at right, to sing and play their instruments. (Courtesy of Socorro County Historical Society.)

Sometimes just getting together with friends was very entertaining. This obviously posed photograph, taken around 1890 by Joseph E. Smith, shows just how much fun it could be to spend an afternoon clowning around. The men look on as the ladies literally "kick up their heels" and toast each other with a glass of lemonade. (Courtesy of Socorro County Historical Society.)

Socorro residents formed an Early Music Ensemble and performed many local concerts. Shown here are, from left to right, (first row) J. Ford, Barry Clark, M. Gaeddert, and Kay Brower; (second row) C. Rutledge, M. Petschek, Ken Ford (New Mexico Institute of Mining and Technology president), E. Brower, S. Thompson, and Betty Clark. (Courtesy of Socorro County Historical Society.)

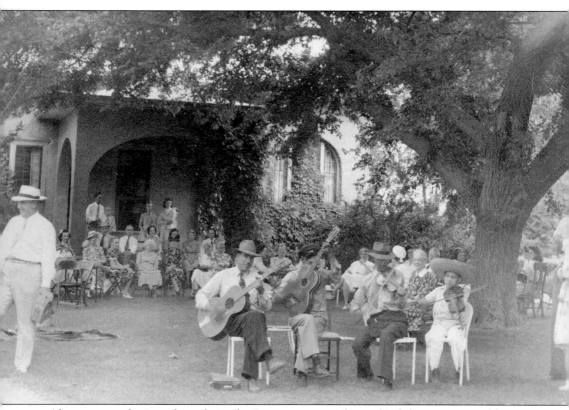

Almost any gathering of people in the Socorro area, such as a birthday party, a wedding, or a political rally, could turn into a concert. These musicians are playing at the home of Charles B. Allaire in San Antonio on August 28, 1944. (Courtesy of Socorro County Historical Society.)

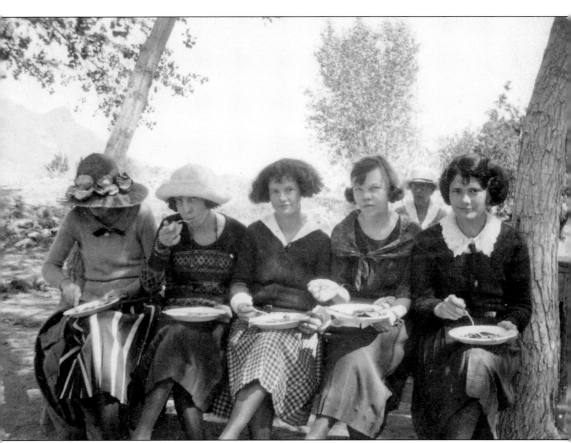

Picnics and potluck dinners were popular forms of entertainment. Holidays, such as the Fourth of July, birthdays, and anniversaries were all occasions in which people gathered to eat. Shown here are, from left to right, unidentified, Isabelle Speare, Virginia Smiley, unidentified, and Winifred Crater. They are enjoying a picnic in the 1920s. (Courtesy of Socorro County Historical Society.)

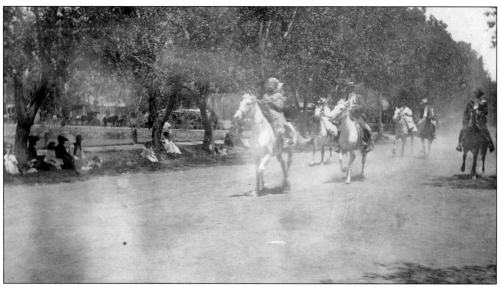

It was customary for residents, men and women alike, to dress in their finest clothes and promenade their horses around the town square on Sundays. Spectators would line the park to take in the show. These riders parade around the park in San Marcial about 1900. (Courtesy of Socorro County Historical Society.)

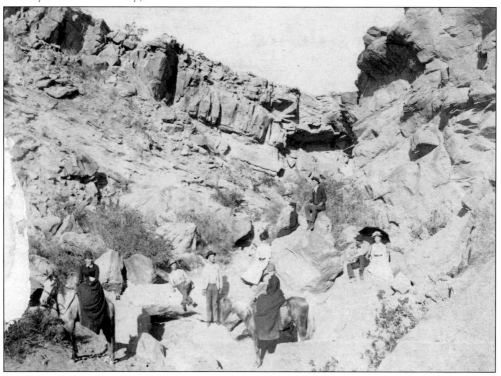

Carthage residents enjoyed going on outings in the mountains near the town. This group was probably photographed sometime around 1890. The ladies in the foreground are mounted sidesaddle, which was probably a challenge in this mountainous terrain. (Courtesy of Socorro County Historical Society.)

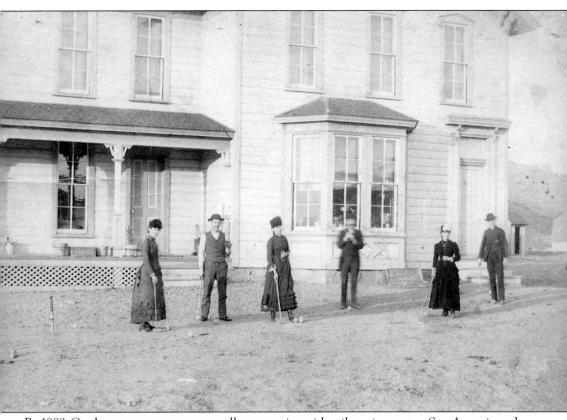

By 1889, Carthage was a prosperous small community, with rail service west to San Antonio and Socorro, a stage connection east to White Oaks, its own school, and an Order of Good Templars hall. Leisure activity included croquet on the lawn, as seen here around 1890. (Courtesy of Socorro County Historical Society.)

Baseball was popular in Socorro and surrounding communities. Contests between teams were always spirited, and rivalries between teams were often intense. Both the Socorro County Courthouse and the Windsor Hotel can be seen in the background of this photograph, taken around 1888. (Courtesy of Suzanne Smith, Joseph E. Smith Collection.)

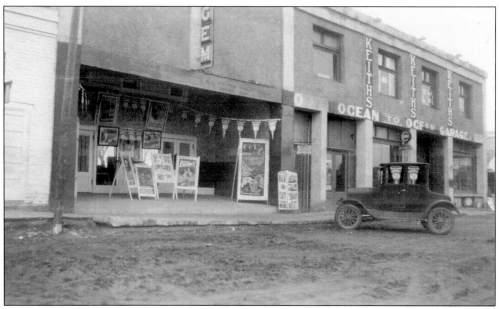

In 1923, Leo Fay came to Socorro to exhibit silent movies in the Gem Theater, located at the south side of the plaza, between Keith's Garage and the Park Hotel. Musical accompaniment for the films was supplied by a Mrs. Fay at a player piano. The Gem Theater evolved into the Loma Theater at the same location. (Courtesy of Socorro County Historical Society.)

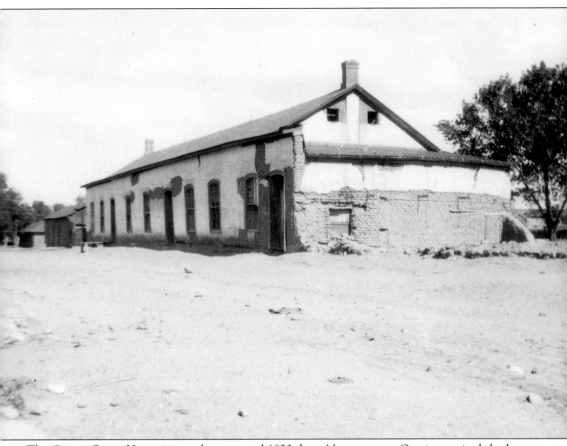

The Garcia Opera House is seen here around 1920. Juan Napomuceno Garcia acquired the lot on which the opera house stands in 1868. It is said that his widow, Francisca Garcia, erected the building as a memorial to her late husband in 1888. She later deeded the building to Abran Abeyta, who sold it to Holm Bursum Sr. in 1917. The opera house has since been restored. (Courtesy of Socorro County Historical Society.)

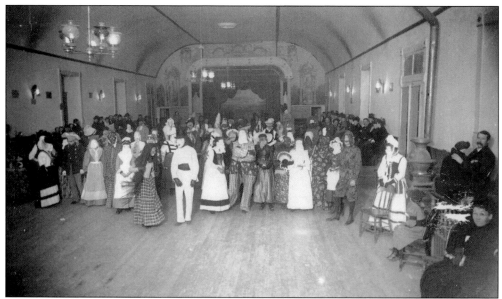

Although there is no record of an opera being performed at the Garcia Opera House, many other events were held there, including Saturday-night dances, and this masquerade ball, photographed by Joseph E. Smith around 1890. Jennie and Maude Wallace performed here, as did theater companies from Chicago, Boston, Philadelphia, and New York City. (Courtesy of Suzanne Smith, Joseph E. Smith Collection.)

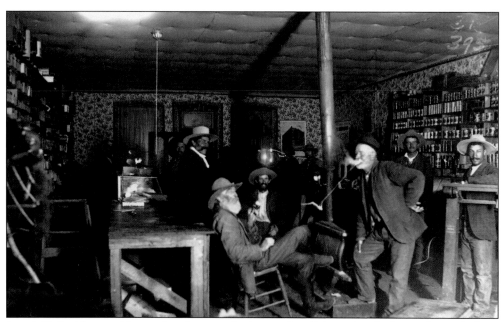

Joseph E. Smith was able to take photographs in very low light, using flash powder made from potassium nitrate mixed with magnesium and aluminum powder, which was ignited to provide illumination. This photograph of a Socorro mercantile store interior was taken using the same technique. (Courtesy of Suzanne Smith, Joseph E. Smith Collection.)

John Wallace Crawford (1847–1917), known as "Captain Jack," was a Civil War veteran and Gen. George Armstrong Custer's chief of scouts. In 1877, he rode 350 miles in six days to carry reports of Gen. George Crook's victory over Sioux chief American Horse. He promised his mother on her deathbed that he would not drink alcohol. He once rode over 300 miles to deliver a full bottle of whiskey to his friend and fellow scout William F. "Buffalo Bill" Cody. He moved with his family to Socorro in 1879, where he was photographed by Edwin Bass. In the 1890s, billed as "The Poet Scout," he embarked on a series of Chautauqua performances. Captain Jack wrote seven books of poetry, four plays, and more than one hundred short stories. (Courtesy of Suzanne Smith, Joseph E. Smith Collection.)

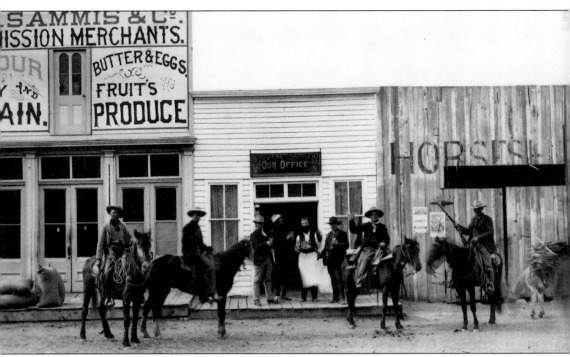

These gentlemen are enjoying a glass of beer outside one of Socorro's many saloons. This cleverly named establishment leads one to surmise that many Socorro residents reported that they had been working late at "Our Office." The fellow raising his glass while seated on his horse indicates that there was no prohibition to drinking and driving. (Courtesy of Suzanne Smith, Joseph E. Smith Collection.)

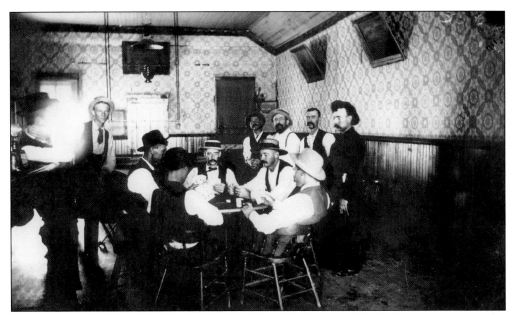

Whether the saloons in Socorro were called pool halls, billiard parlors, sampling rooms, or just plain saloons, they served the same purpose: a gathering place where (mostly) men could get the latest news, make business deals, or take part in a card game while enjoying the beverage of their choice. This photograph was taken inside an unspecified saloon in Socorro by Joseph E. Smith around 1888. (Courtesy of Suzanne Smith, Joseph E. Smith Collection.)

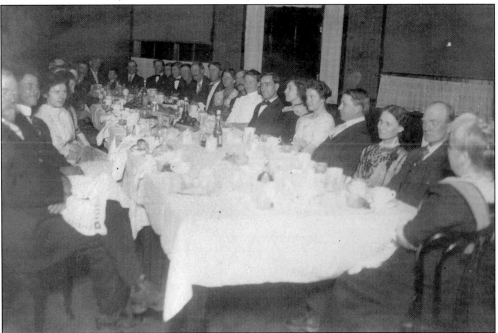

The *Socorro Chieftain* reported on January 11, 1913, that the Gem City Lodge No. 7, International Order of Odd Fellows, held a banquet and installation of officers at the Chambon Hotel. The newspaper reported, "Here plates were laid for thirty-two persons all of whom did justice to the good things placed before them." (Courtesy of Suzanne Smith, Joseph E. Smith Collection.)

This photograph was taken in Petty's Drug Store in the 1930s. The soda fountain, a fixture of most drugstores, was a popular destination for young people after school or while on a date. The young man pictured here could probably afford two drinks, but it would not be nearly as much fun. (Courtesy of Socorro County Historical Society.)

The *Socorro Chieftain* reported in 1897: "Yesterday the city marshal began taking up some of the herds of burros that have been roaming the streets for the past few months destroying gardens, young fruit trees, and everything else edible to a burro. This is a move in the right direction and should be kept up." (Courtesy of Socorro County Historical Society.)

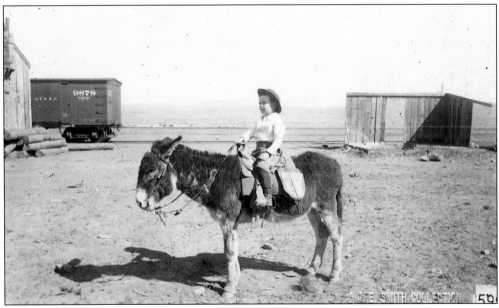

When the city marshal rounded up the stray burros that were creating a nuisance around the town, the *Socorro Chieftain*, and most residents, applauded the efforts. Those most upset with these actions, however, were the children of Socorro. For them, the burro roundup was the equivalent of chaining up their bicycles, for, indeed, the burros were handy transportation for the kids in town. (Courtesy of Suzanne Smith, Joseph E. Smith Collection.)

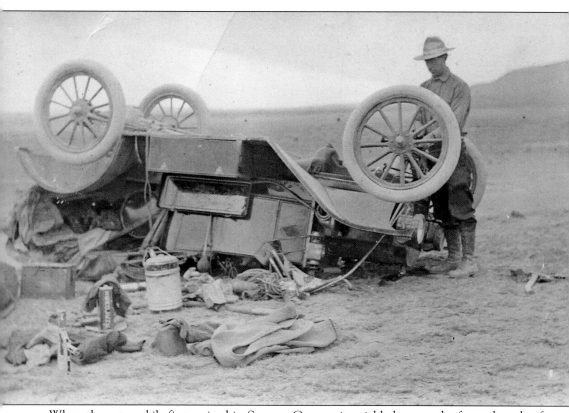

When the automobile first arrived in Socorro County, it quickly became the favored mode of transportation. Vehicles with a high center of gravity and rough roads that were meant for horse-drawn wagons caused many rollover accidents. Filling stations were rare at first, and running out of gas was a common occurrence. (Courtesy of Socorro County Historical Society.)

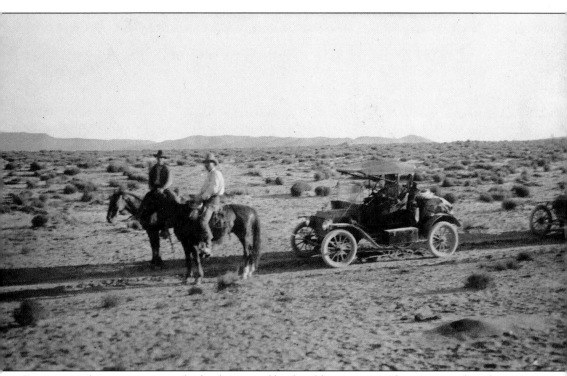

Sometimes, the new generation had to be rescued by the old generation. The transition from livery stables to service stations is embodied in this photograph, taken about 1912. It is unknown what the charge was for this "wrecker" call. (Courtesy of Socorro County Historical Society.)

Discover Thousands of Local History Books
Featuring Millions of Vintage Images

Arcadia Publishing, the leading local history publisher in the United States, is committed to making history accessible and meaningful through publishing books that celebrate and preserve the heritage of America's people and places.

Find more books like this at
www.arcadiapublishing.com

Search for your hometown history, your old stomping grounds, and even your favorite sports team.